AROUND SOLIHULL
THROUGH TIME
Anthony Poulton-Smith

Acknowledgements

Sue Doyle – Page 05 top

Bruce Pountney – Page 07 top

Ian Davies – Page 14 top; Page 15 top; Page 16 top; Page 17 top; Page 18 top; Page 19 top; Page 20 top; Page 21 top; Page 22 top; Page 23 top; Page 24 top; Page 25 top; Page 26 top; Page 27 top; Page 28 top; Page 29 top; Page 30 top; Page 31 top; Page 32 top; Page 33 top; Page 34 top; Page 35 top; Page 36 top; Page 39 top; Page 80 top; Page 81 top; Page 82 top; Page 83 top; Page 84 top; Page 85 top; Page 86 top; Page 87 top; Page 88 top; Page 89 top; Page 90 top; Page 91 top; Page 92 top; Page 93 top; Page 94 top; Page 95 top; Page 96 top

Ken Bate – Page 37 top

Geoff Dowling – Page 40 top; Page 41 top

Roy Holloway – Page 42 top; Page 69 top

Steve Richards – Page 06 top; Page 43 top; Page 44 top; Page 45 top; Page 46 top; Page 47 top; Page 48 top; Page 49 top

Sue Ernst – Page 67a

Clive Hinsull – Page 70 top; Page 71 top; Page 72 top; Page 73 top; Page 73 top; Page 74 top; Page 75 top; Page 76 top; Page 77 top; Page 78 top; Page 79 top

The Knowle Society – Page 10 top; Page 52 top; Page 55 top; Page 56 top; Page 57 top; Page 58 top; Page 59 top; Page 60 top; Page 61 top; Page 63 top; Page 64 top; Page 65 top; Page 68 top

John Wright – Page 11 top; Page 12 top; Page 13 top

Jackie Richards – Page 50 top; Page 51 top; Page 53 top

Flickr.com/ricsrailpics – Page 54 top

Rose Hamilton – Page 66 top; Page 66 inset

Les Clarke – Page 38 top

First published 2012

Amberley Publishing
The Hill, Stroud, Gloucestershire, GL5 4EP
www.amberley-books.com

Copyright © Anthony Poulton-Smith, 2012

The right of Anthony Poulton-Smith to be identified as the Author of this work has been asserted in accordance with the Copyrights, Designs and Patents Act 1988.

ISBN 978 1 4456 0951 5 (print)

British Library Cataloguing in Publication Data.
A catalogue record for this book is available from the British Library.

Typesetting by Amberley Publishing.
Printed in Great Britain.

Introduction

For an Anglo-Saxon settlement, Solihull's beginnings are quite late. For a town of this size we would normally expect to find some mention of a settlement well before the time of Domesday and yet while the great tome records Ulverlei and Longdon, Solihull is conspicuous by its absence.

While the name of Solihull – it describes 'the pig sty on a slope' – was undoubtedly in use by the early eleventh century, the place was little more than a trading post, a central hub where representatives from outlying villages came to barter. By 1220 the parish church of St Alphege was founded and just twenty-two years later a weekly market had been granted and thus Solihull became the local centre for commerce. Meanwhile, Knowle had come to the fore as the ecclesiastical centre. While the two villages prospered and grew, the surrounding villages became very much the small communities we see today.

Slow growth continued over the ensuing centuries. Records show trading in weapons for hunting and tools for agriculture. So many worked as blacksmiths that it led to a natural deforestation of the region as wood was in such great demand. That any growth in population took place at all was likely down to the various halls built in the vicinity, bringing employment to an area that industry had largely ignored.

Not until the coming of the railways did Solihull really begin to expand. A reliable and rapid transport system meant those who worked in nearby Birmingham could commute on a daily basis, something that continues to this day. Increased population attracted businesses, most notably the car manufacturer Rover, and the resulting prosperity kick-started an expansion that has seen the boundary between Solihull and neighbouring Birmingham become much less well-defined over the last century or so.

Numbering 20,000 at the end of the First World War, the population had more than trebled twenty years later, by which time the country was at war once more. Today the borough is home to almost 100,000 individuals and yet the town still has a distinct semi-rural feel. Anyone visiting the outlying villages and hamlets will instantly realise why

these are among the most desirable places to live anywhere in the Midlands and beyond.

Most of the population live in the districts of Castle Bromwich, Chelmsley Wood, Fordbridge, Kingshurst, Marston Green, Shirley and Smith's Wood, and of course Solihull itself. Smaller settlements include Knowle, Olton, Dorridge, Balsall Common, Meriden, Elmdon, Bickenhill, Lyndon, Tanworth, Hockley Heath and Earlswood. Residents and natives of Solihull are referred to as Silhillians, although whether Silhill House came before this reference or because of it is not known.

While Solihull initially benefited from the arrival of the railway, it is also handily placed for the roads. Both the Warwick Road (A41) and Stratford Road (A34) run through its borders, as they have for many years, with the arrival of the M42 and M40 in the last thirty years having brought the motorway network within easy reach.

Since the 1960s the borough has undergone many changes. Hardly a year seems to pass without some building springing up, a road being laid or closed off for pedestrians. Undoubtedly the biggest change in the town centre has come in the shape of Mell Square. In the outskirts, aside from the motorways, the biggest change came in the form of what was Elmdon Airport, but is now Birmingham International Airport, and the nearby National Exhibition Centre.

Within these pages we shall look at the changes over the last century or so. Not only in terms of the town and surrounding villages but also the people and the places where they lived, worked and even shopped. Almost 200 images, old and new, enable the reader to share the changes and it may come as a surprise to find out what has changed and what is still very much recognisable a century later.

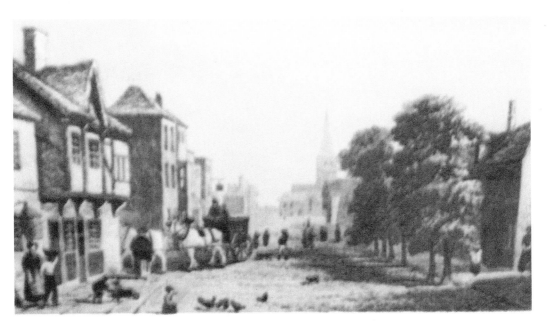

High Street

Looking along High Street towards St Alphege church today, the thoroughfare is traffic-free. The earlier view is an image captured in 1829, when there was not only more traffic than today but also infinitely more chickens.

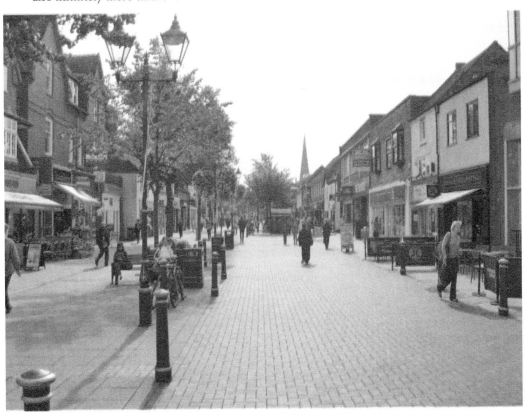

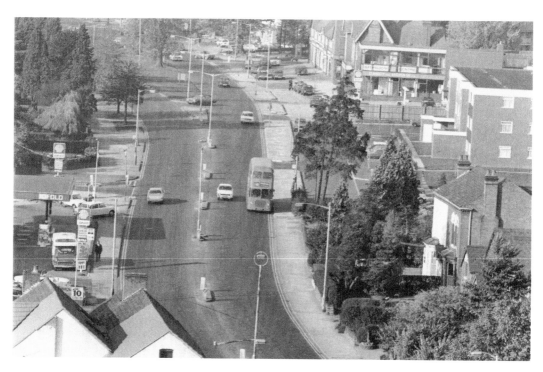

Stratford Road, Shirley
A view of Stratford Road, Shirley, is no longer possible from this vantage point, yet what were the petrol station and shops on the left can still be seen.

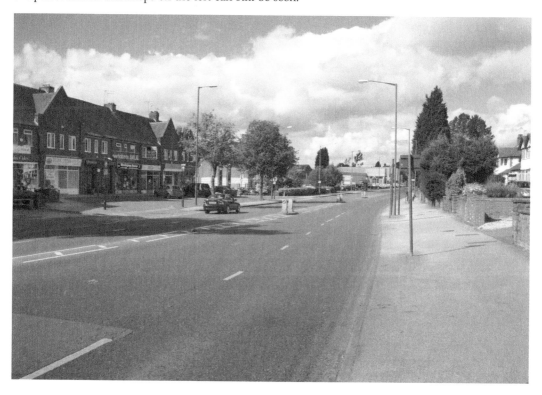

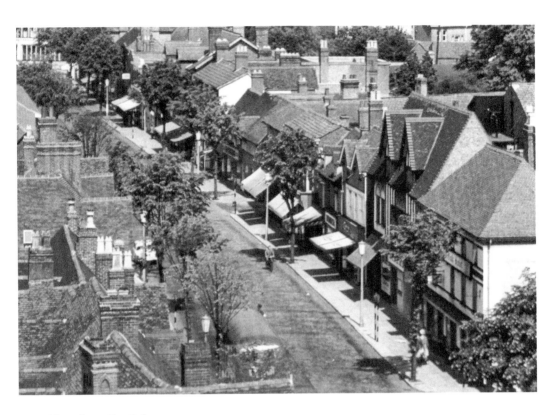

View from the Spire

Solihull High Street is viewed from the church spire around 1960, with as yet no sign of Mell Square. Below is the modern front view of Solihull's parish church, which is dedicated to St Alphege, who was Archbishop of Canterbury until martyred by Danish raiders on 19 April 1012. The new development of Mell Square is also shown.

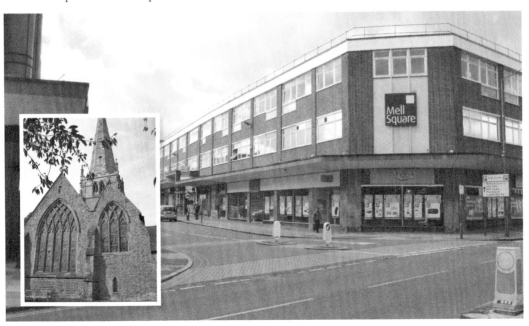

The Manor House

While there are 102 years between the two images, the Manor House in High Street has hardly changed at all. Built around 1495, this timber-framed building may be known as the Manor House but it has never been home to the Lord of the Manor. However, it has put a roof over the heads of the Greswolde family, the local doctors, and the Home Guard.

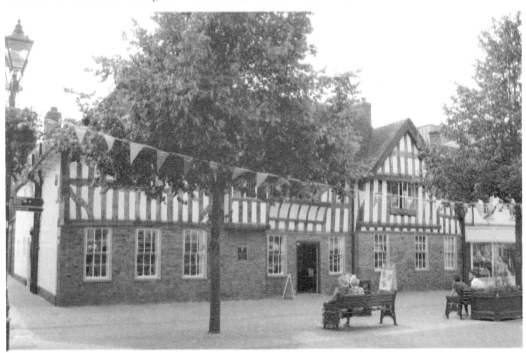

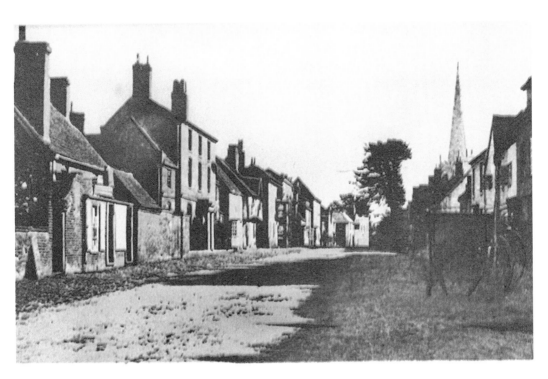

High Street

High Street in 1853 and again in 2012. There are more trees today, something seen again and again throughout this book.

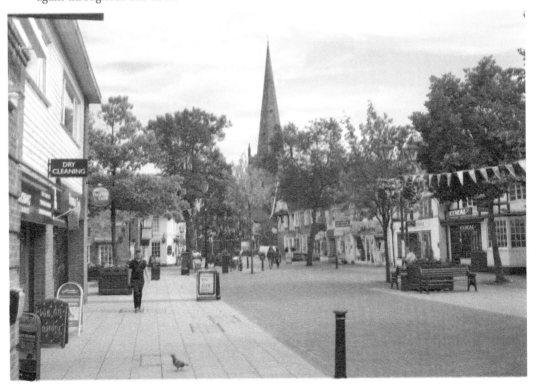

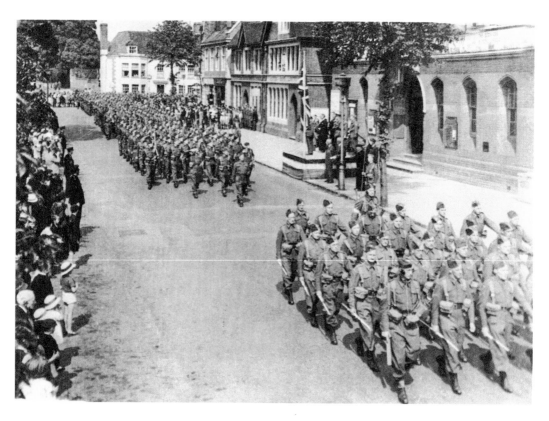

Poplar Road

Where the Home Guard once paraded along Poplar Road, vehicles now approach the modern multi-storey car park.

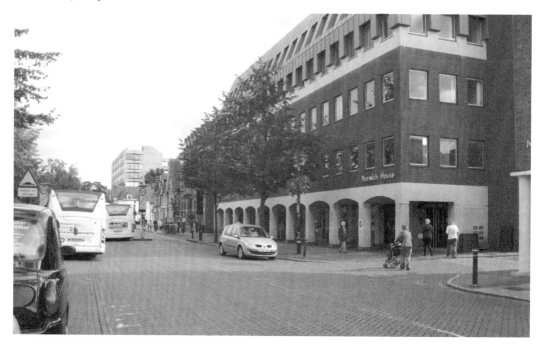

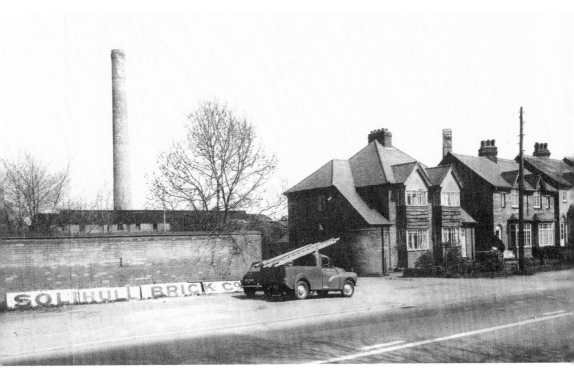

Brickworks
The former Solihull Brickworks stood opposite Malvern Park. What we see here is the entrance, now roughly the mouth of Riverside Drive.

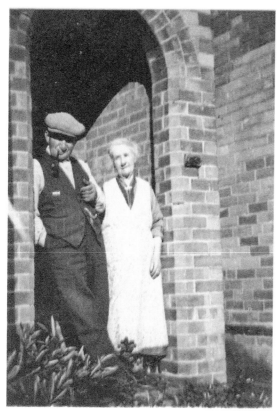

Warwick Road

Here are Charles and Ellen Beale, grandparents of John Wright (owner of the photograph). Their house was along Warwick Road from the brickworks and, while none of the original houses remain today, the position of their home can be traced by the position of the old post box, which remains *in situ*.

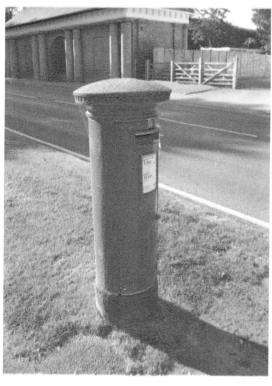

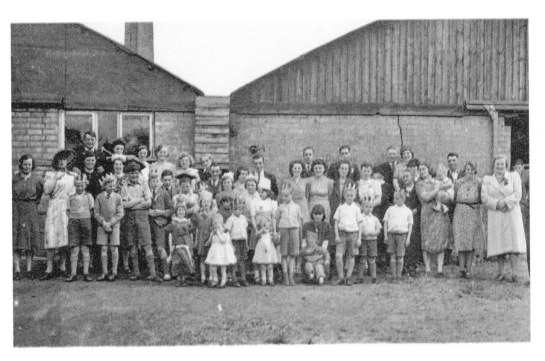

A Brickworks Party

The brickworks again, this time in a group photograph taken at a children's party. This may have been taken around the end of the Second World War, possibly even on VE Day.

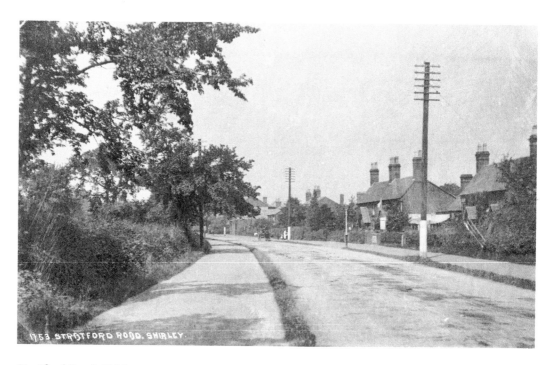

Stratford Road, Shirley

Stratford Road is pictured exactly 100 years ago. Today the scene is very different, with four lanes of traffic making crossing difficult.

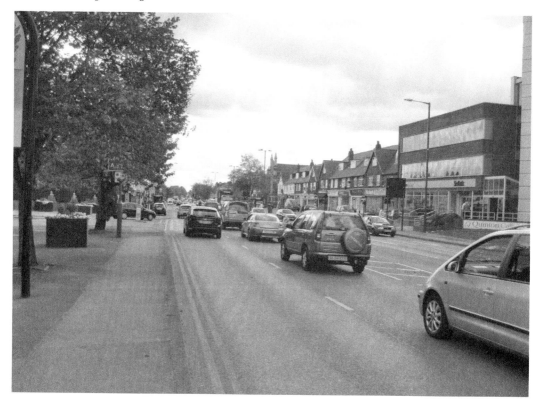

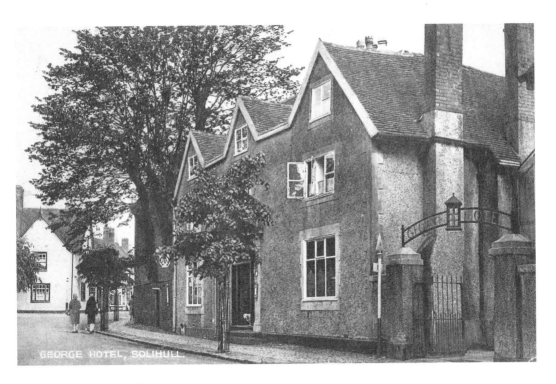

The George Hotel

The George Hotel, opposite the church, dates from at least the sixteenth century. As can be seen from the old image, the building has changed much over the years. Today restoration makes it appear more like it did when first built, hence in the old image the building actually looks more modern.

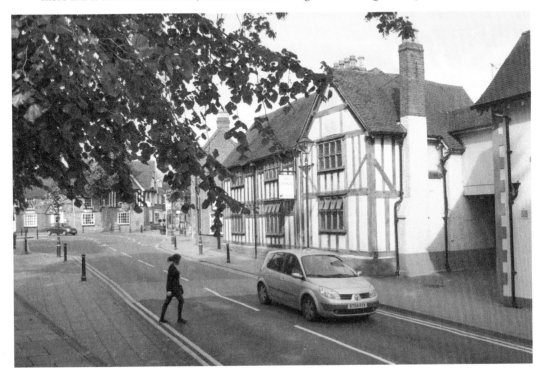

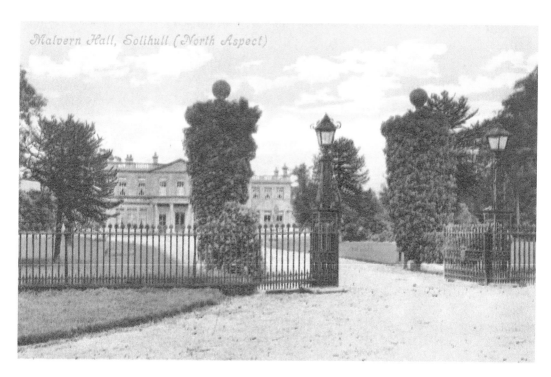

Malvern Hall, Solihull (North Aspect)

Malvern House

Malvern House is virtually unrecognisable today. The top (third) storey of the building was removed in the nineteenth century, and the grounds are now largely given over to parkland, with the estate gates doubling as the modern park entrance.

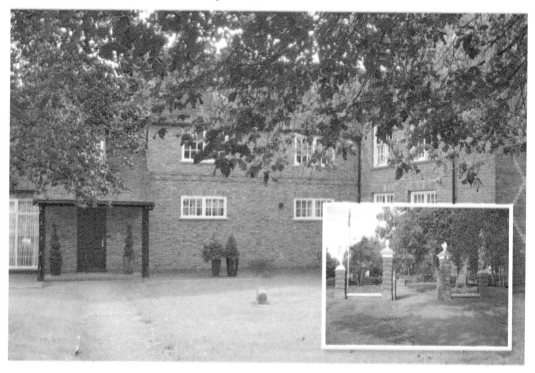

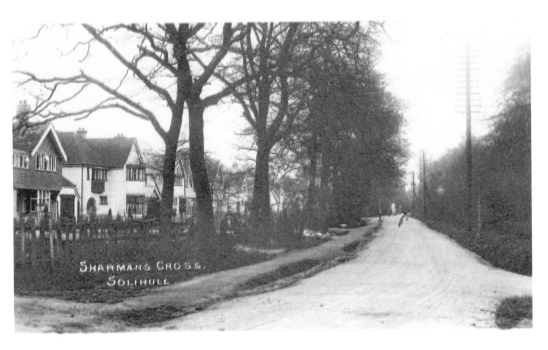

Sharmans Cross

The old photograph of Sharmans Cross Lane is thought to be from the 1930s. The lane took its name from Sharmans Cross Farm

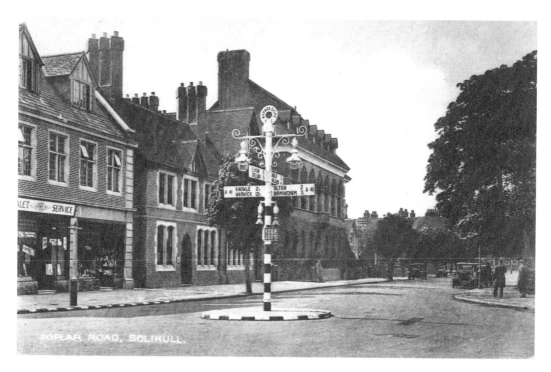

The Old Town Hall

The large building in the centre is the former town hall and to its left is the old police station. Both are still recognisable today, though they have very different uses. Yet surely the best part of this image is the signpost. If only modern signs were so ornate.

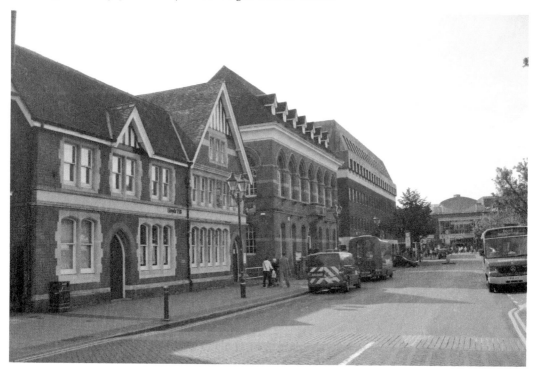

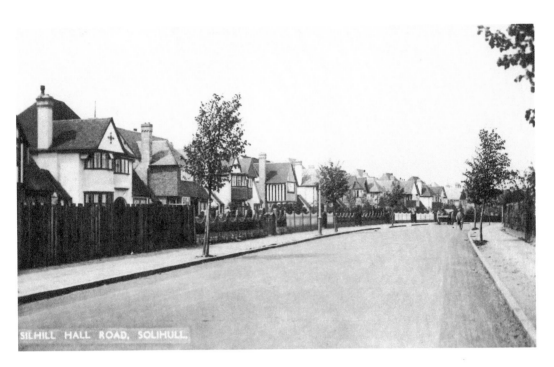

Silhill Hall Road

Natives and inhabitants of Solihull are known as Silhillians. Silhill Hall Road takes its name from Silhill Hall. It seems unlikely the term was derived from the place or vice versa; more likely they share a common ancestry.

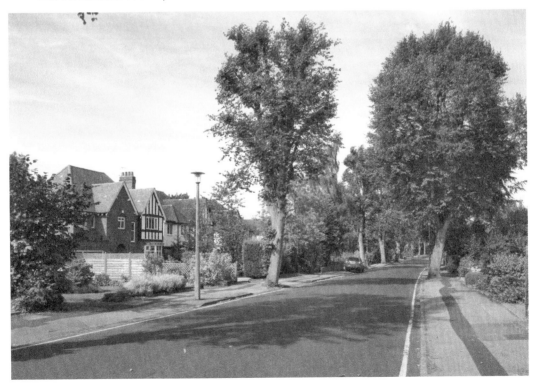

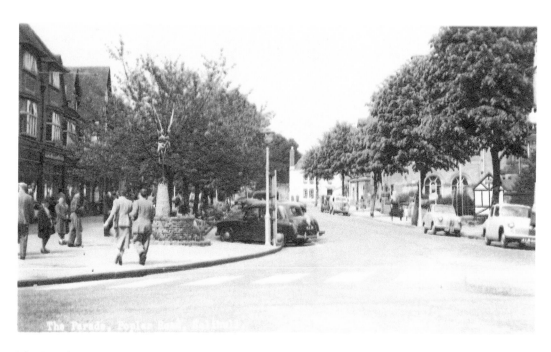

The Parade

The Parade, Poplar Road, looking towards Warwick Road where Brueton Gardens and the memorial clock are now found.

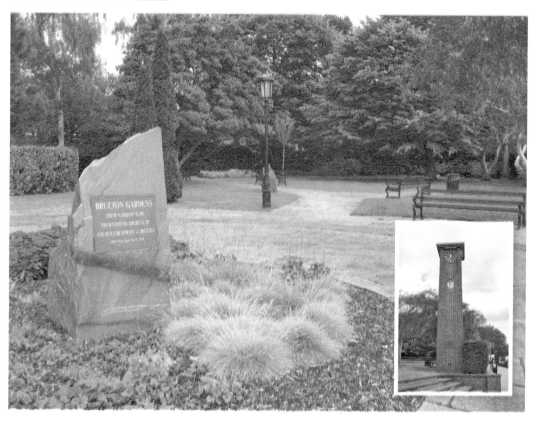

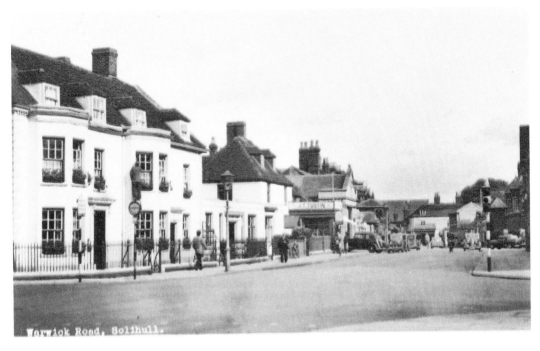

Warwick Road

Apart from the two white buildings on the left of Warwick Road, nothing of the old image remains today.

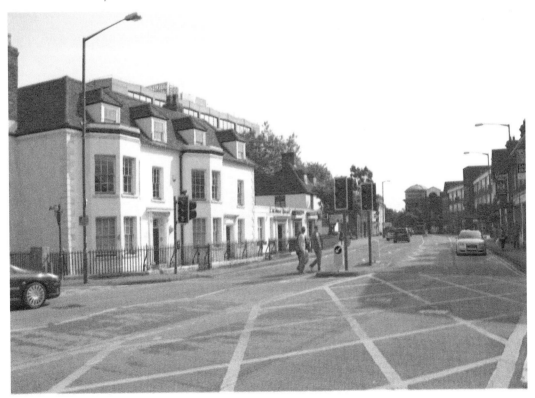

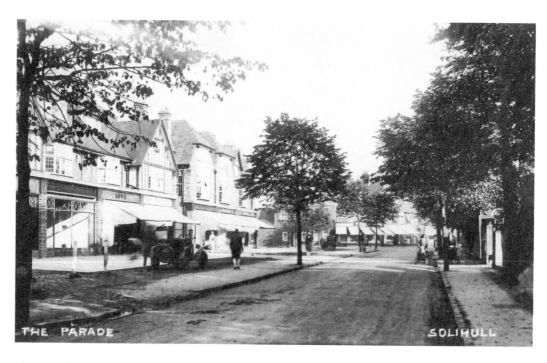

The Parade

A much wider thoroughfare today in Poplar Road. It was once commonplace for a row of shops providing for a household's general needs to be known as the 'Parade'.

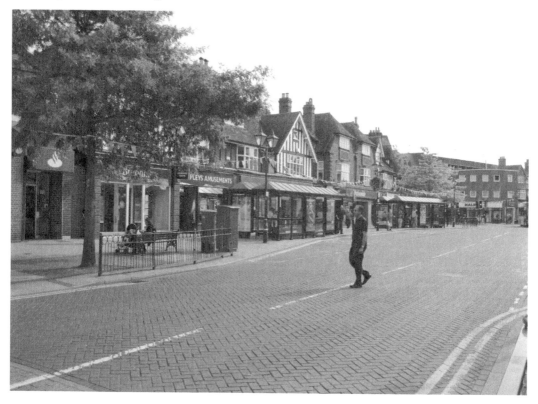

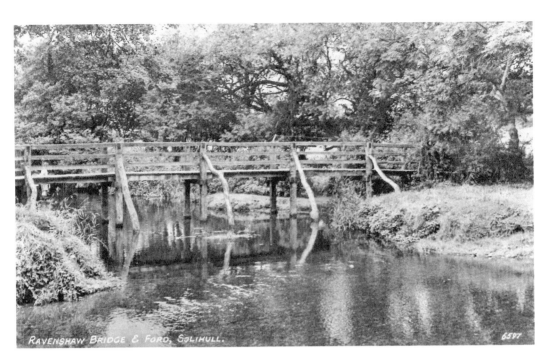

RAVENSHAW BRIDGE & FORD, SOLIHULL. 6587

Ravenshaw Bridge

Ravenshaw Bridge and Ravenshaw Ford before 1950. The lane still bears the name of Ravenshaw and comes down to the bridge and ford. Today, the bridge has been replaced and the ford is much overgrown but still very recognisable.

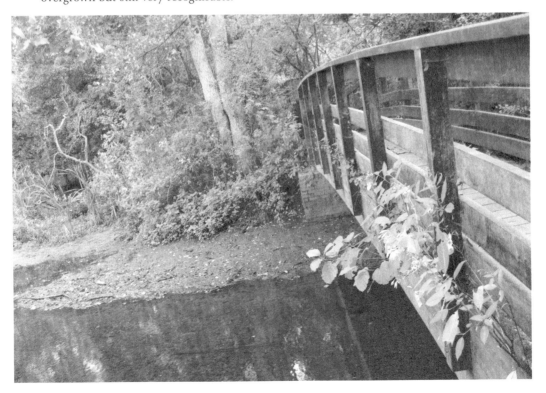

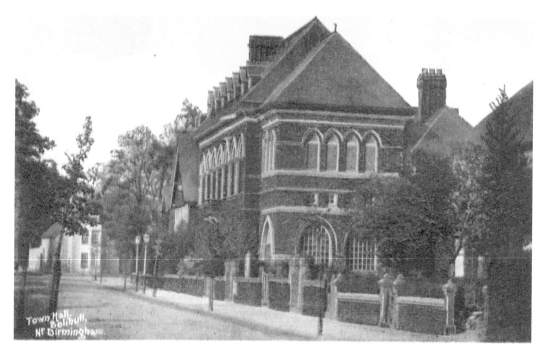

Assembly Rooms

The former town hall is now known as the Assembly Rooms and is part of the J. D. Wetherspoon's chain. The modern name reflects the original use, for it was built around 1880 as the public hall and only became the town hall in 1932.

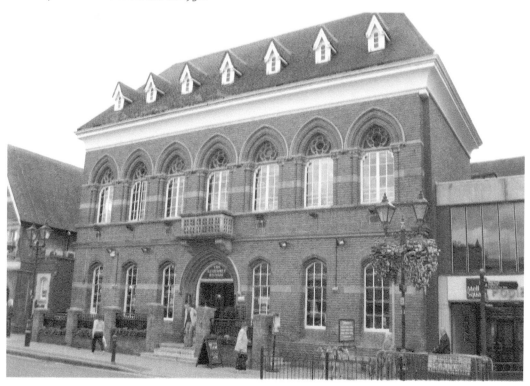

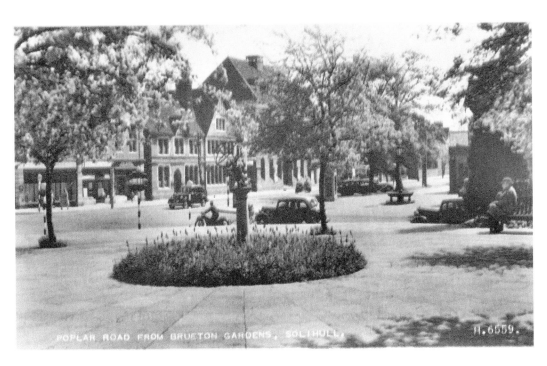

Poplar Road

Poplar Road, looking from Brueton Gardens. The former town hall and the old police station are largely unchanged.

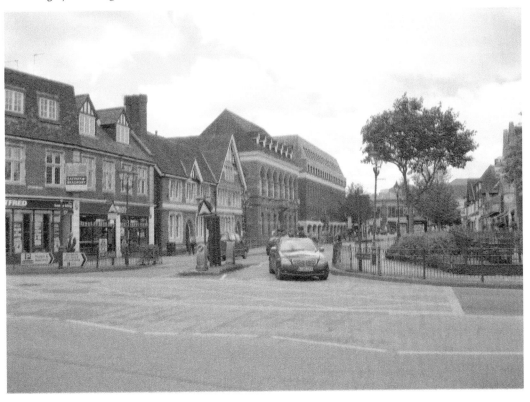

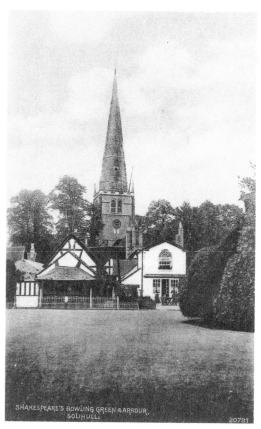

SHAKESPEARE'S BOWLING GREEN & ARBOUR,
SOLIHULL.

20791

Bowling Green
Shakespeare's Bowling Green at the rear of the old George Hotel, with the spire of St Alphege beyond. Aside from the addition of the modern Ramada George Hotel, the scene is clearly the same and the bowlers are still in evidence.

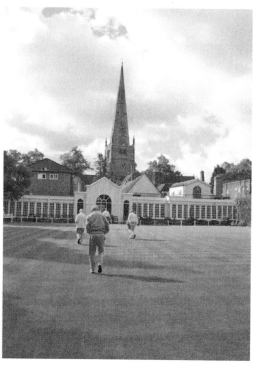

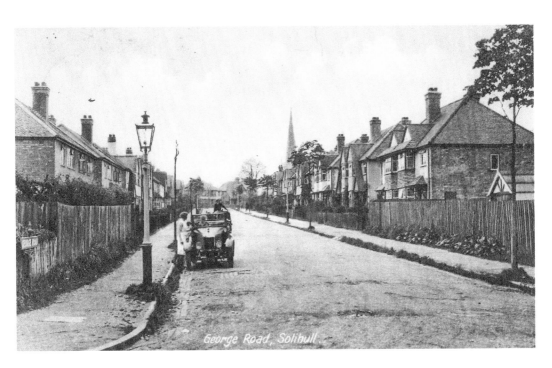

George Road
Hardly anything of the original George Road remains; even its path has been changed.

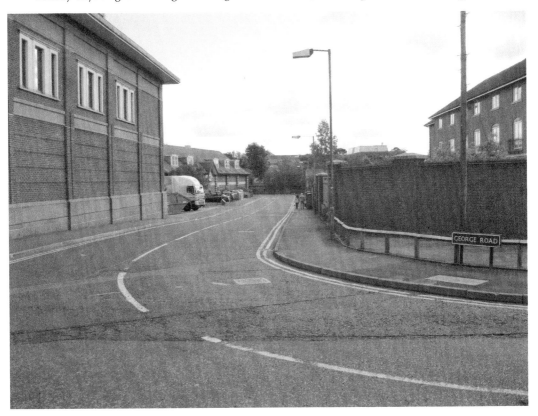

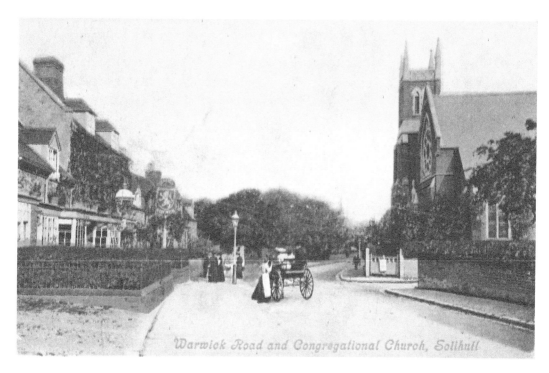

Warwick Road and Congregational Church, Solihull

Warwick Road

What appear to be two different views are actually of the same location, albeit separated by a century or so. Aside from the bend in the road, the only marker we have is the pub on the left. What was the Golden Lion is now the Town House.

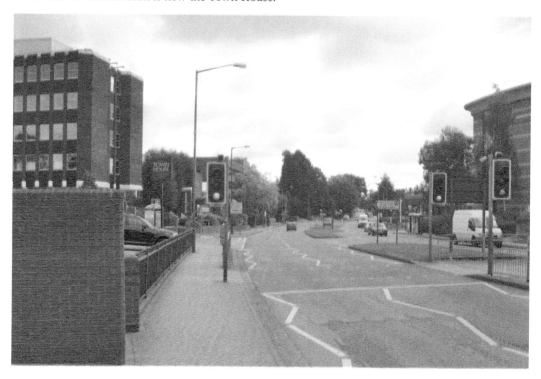

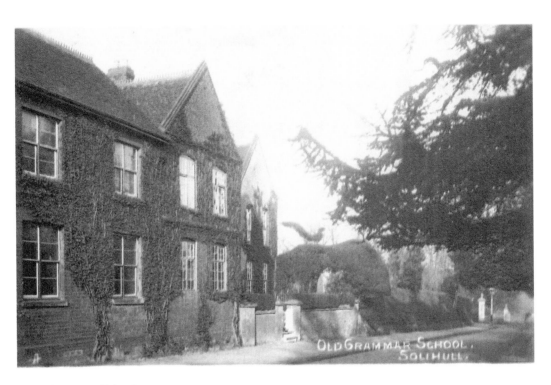

Grammar School
The Old Grammar School on Cedarhurst, near Malvern Park.

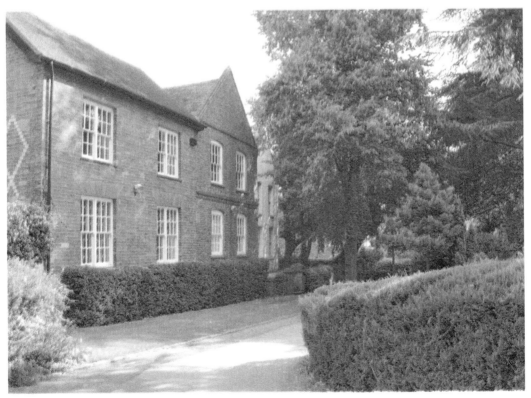

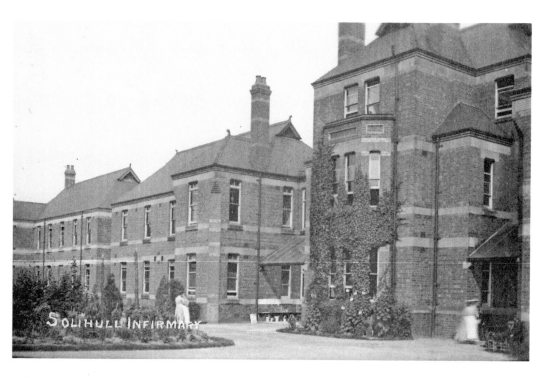

Infirmary

Solihull Infirmary was allied to the former workhouse but later became a part of Solihull's Hospital.

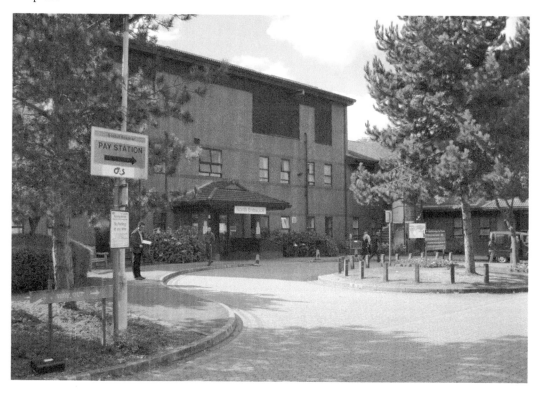

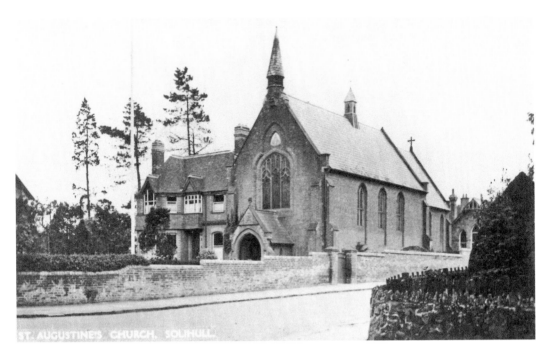

St Augustine's Church
St Augustine's church was built on land donated by Hugford Hassall in 1760. The present building dates from 1839 and has seen surrounding buildings encroaching in the last 150 years.

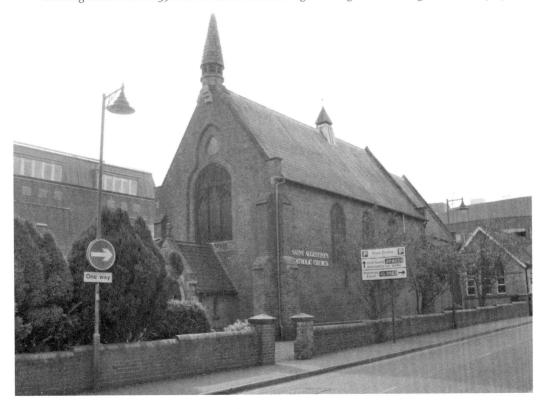

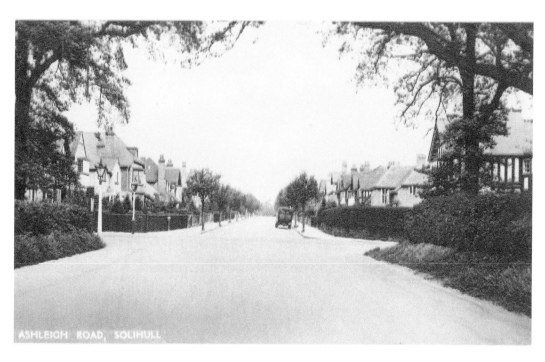

Ashleigh Road

Ashleigh Road has actually changed very little, other than the pavement, the road surface and the avenue of trees.

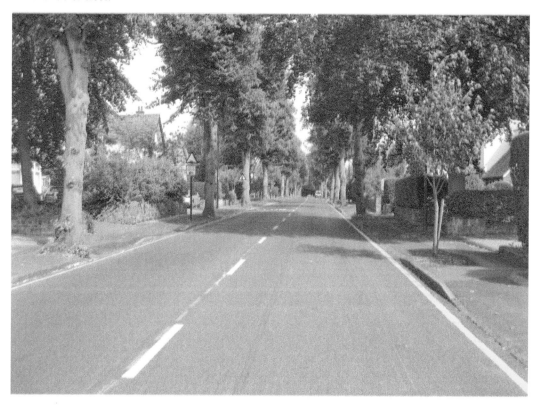

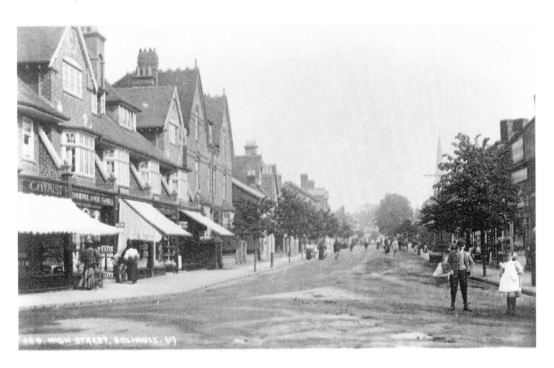

High Street

Pedestrianised in 1994, High Street was so named because it was the most important thoroughfare, and it remains so in the twenty-first century.

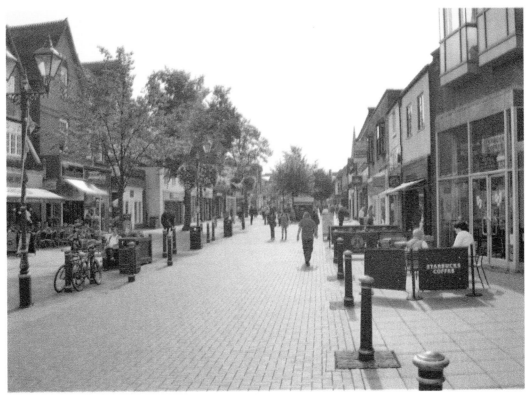

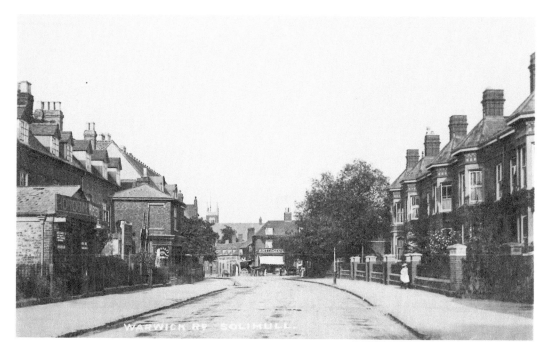

Saddlers Arms

Warwick Road, to the south of the town centre. The tower of the Congregational church can just be seen in the distance. The modern Saddlers Arms stands on the right-hand side of the road in the distance, just where it bends away to the left.

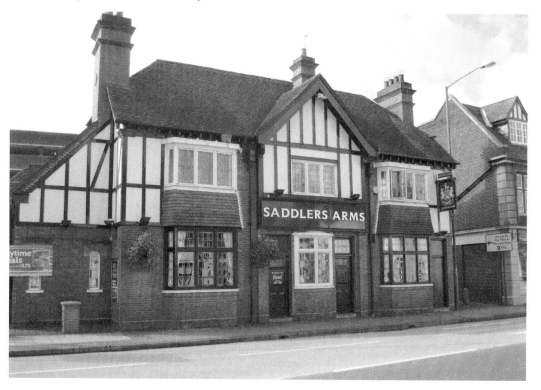

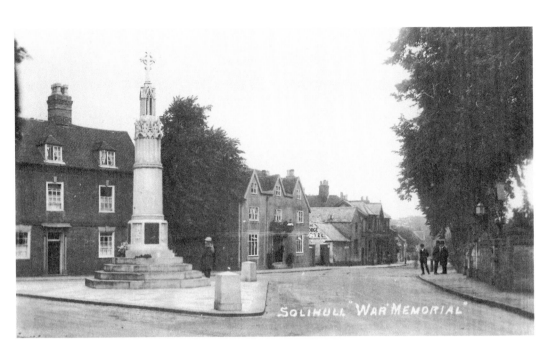

War Memorial

The most obvious differences in the war memorial are the plaques on the upper column. On the early photograph the names are First World War losses only; 100 years later, Second World War victims have been added and the memorial recently refurbished.

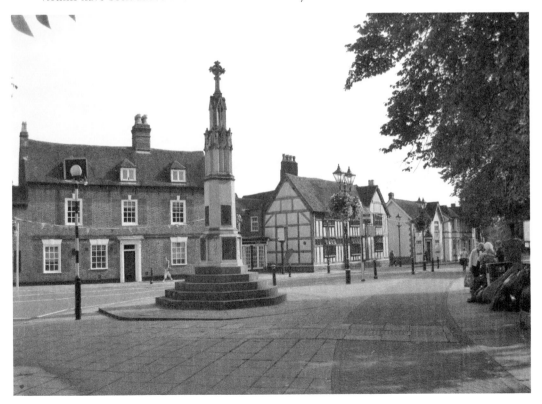

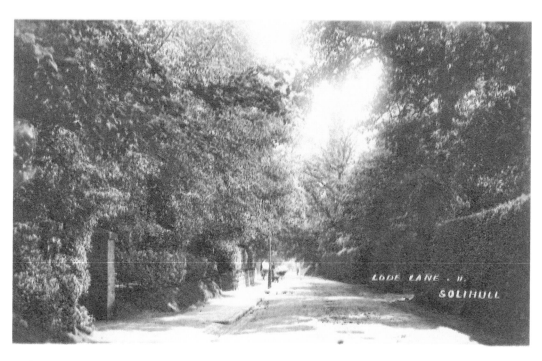

Lode Lane

There is less than a century between the two images and yet no part of Lode Lane looks as it did in the earlier image.

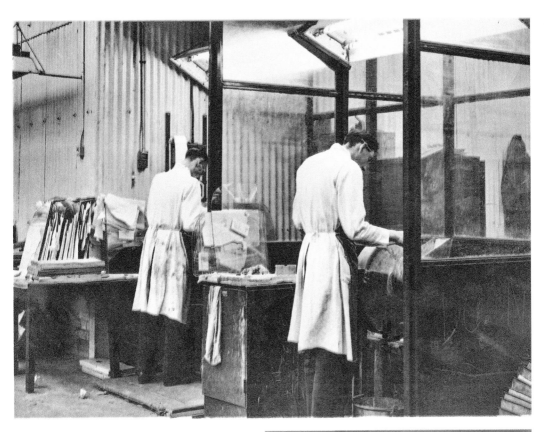

Rover

Inside the Rover factory. This photograph was taken by John Toft Bate, probably around 1948. The man on the right is his son Victor. He was identified in the photograph by grandson Ken. The glass they are working on is the rear window of a Rover P3.

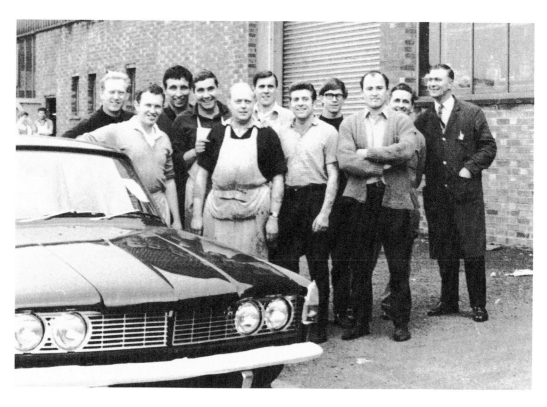

Mell Square

Workers on the Rover assembly line of the 1960s, having produced a Rover P6, would never have recognised Mell Square.

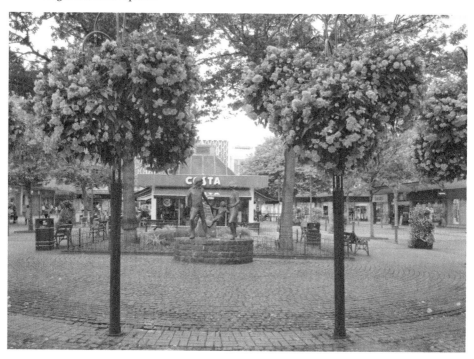

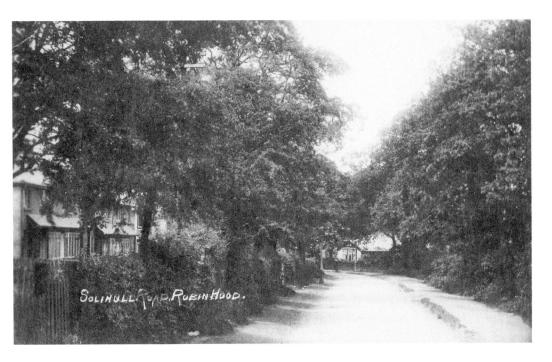

Robin Hood Lane

These are images of Robin Hood Lane. What was originally a country lane has, in more recent years, looked out of place as a dual carriageway, with it being a comparatively short road in a much prized residential area.

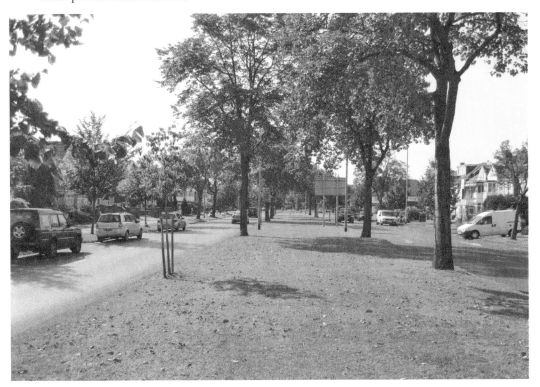

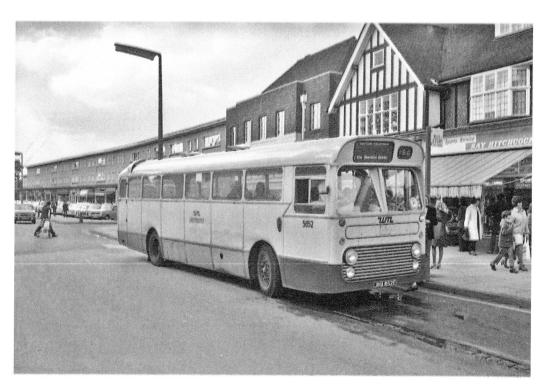

Buses

Frequent bus services brought shoppers to Solihull from near and far in 1975.

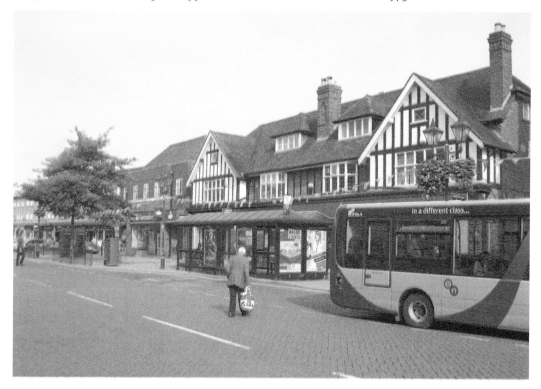

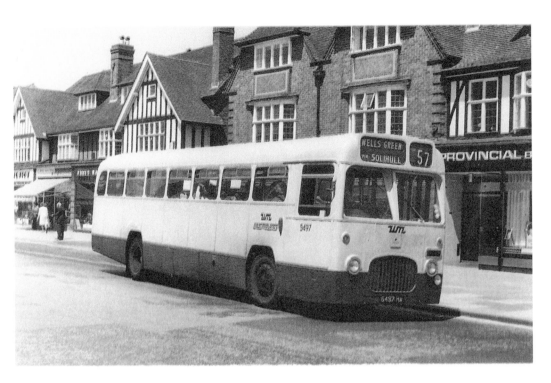

Buses

The old single-decker buses in the photograph and the one on page 40 were both manufactured by the Birmingham & Midland Motor Omnibus Company. The BMMO had officially changed its name the previous year, and was thereafter known as Midland Red.

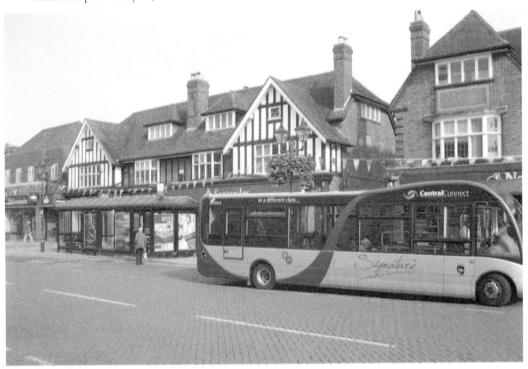

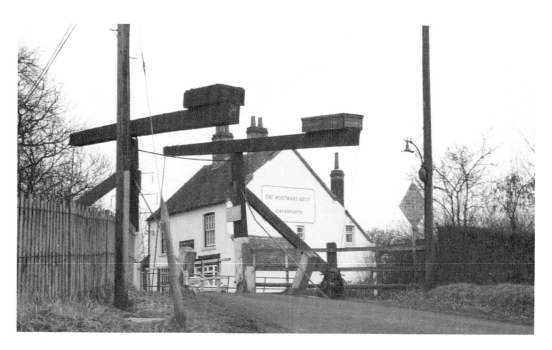

Drawbridge

While the original drawbridge was counterbalanced to allow operation by hand, the modern electronic version requires only the press of a button. Note the modern pub is a new building and named the Drawbridge, while the old establishment was named the Boatmans Rest.

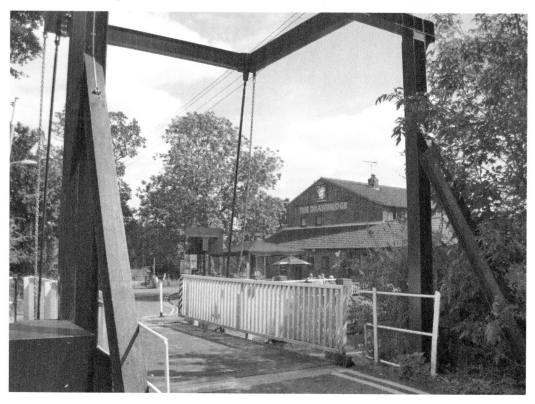

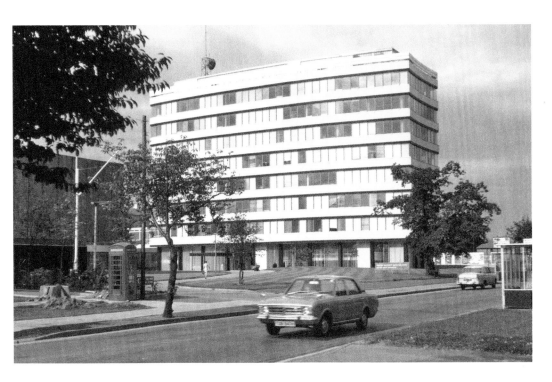

Electricity Board

Central Electricity Generating Board offices around the end of the 1960s. While the exterior of the building has hardly changed, inside it is now quite empty.

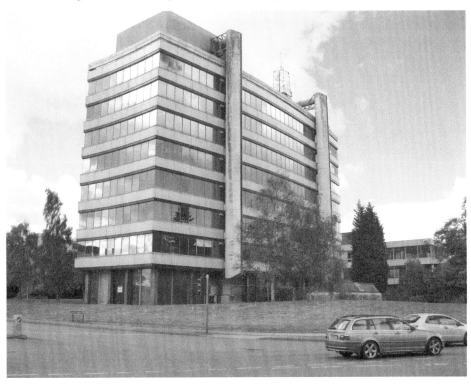

Ministry of Defence

The former Ministry of Defence properties here have been demolished and the area is currently under redevelopment.

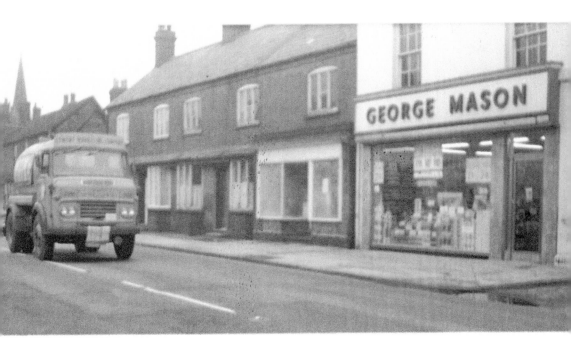

George Mason

The once ubiquitous grocery chain of George Mason on High Street in 1968. High Street is now pedestrianised.

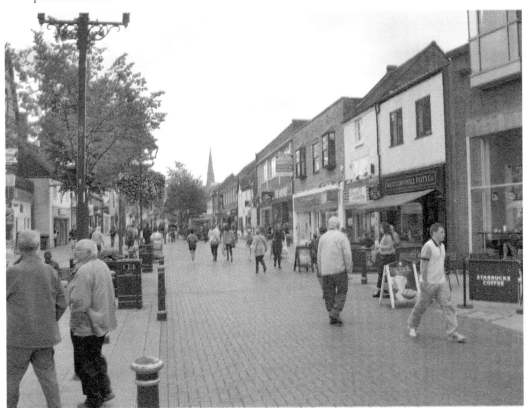

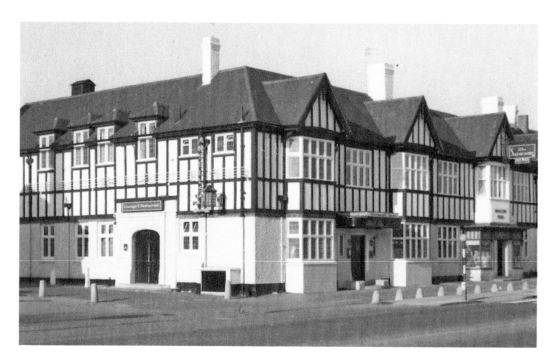

The Saracens Head

The Saracens Head in 1969 looks little different from the modern version, but only on the outside. This was once a more common pub name and showed the landowner or landlord's family had ancestors who had fought in the Holy Land during one of the Crusades.

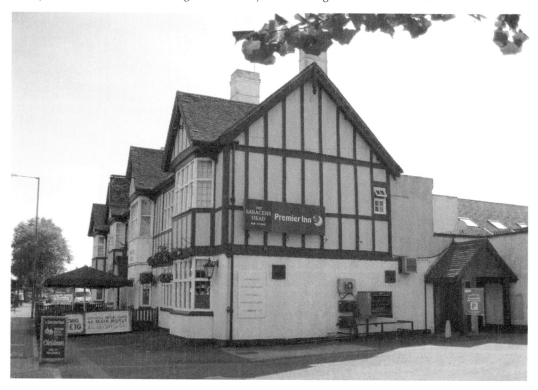

Marshall Lake Road
Marshall Lake Road, in 1966; the weather was little different to today.

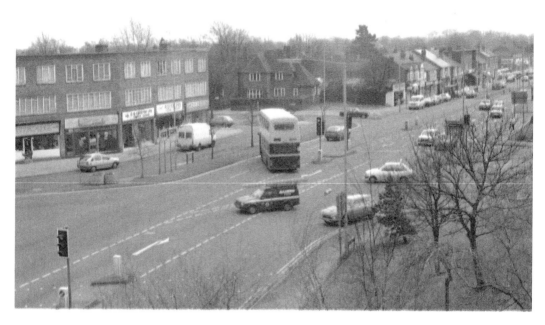

Stratford Road Junction

The junction of Stratford Road and Haslucks Green Road. The passage of time is seen in the trees on the far side of the road – barely saplings in the 1980s, they are mature trees today.

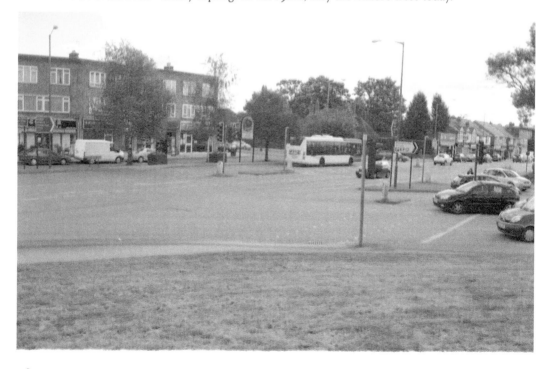

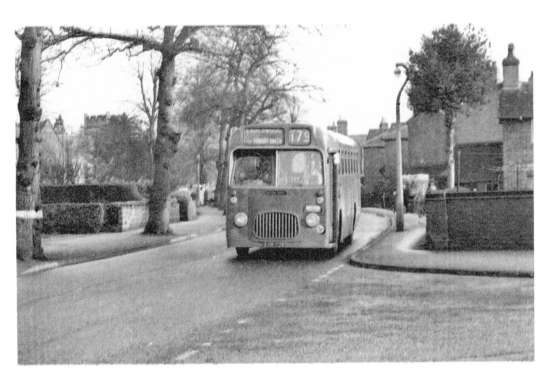

Changing Roads
In the forty years between the two photographs little has changed except for the buses.

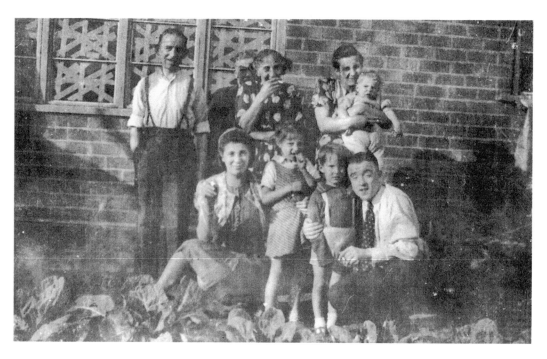

Dig For Victory

Maggie and Doris Handy, pictured at 42 Moat Lane during the Second World War. Grandfather Bill answered the call to 'Dig For Victory', as can be seen from the cabbages in the foreground. It would be interesting to know how many of these people have seen Solihull's library and arts complex.

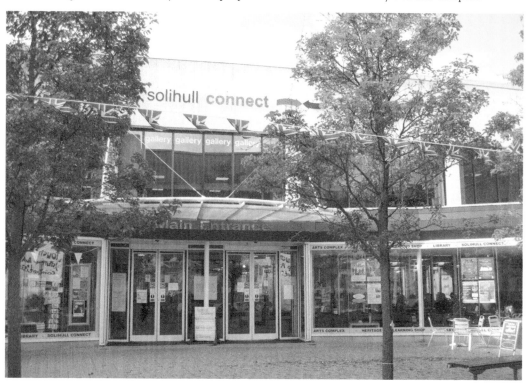

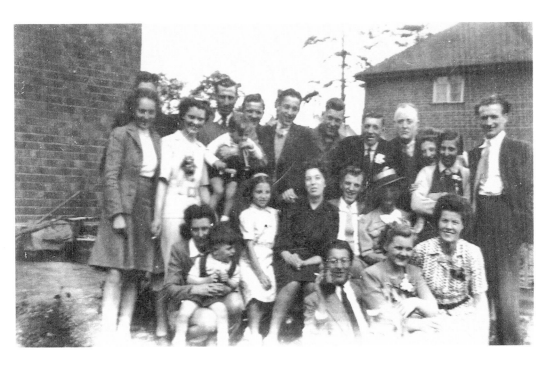

Touchwood Centre

The Handy and Berry families pictured before 1952, probably also at 42 Moat Lane. The flowers worn on the lapels indicate this photograph was taken on the occasion of a wedding. Have any of this group shopped at the Touchwood Centre?

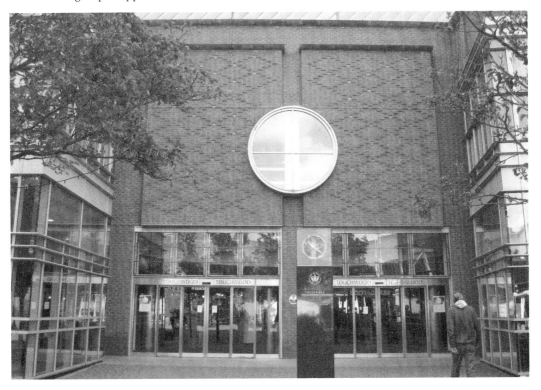

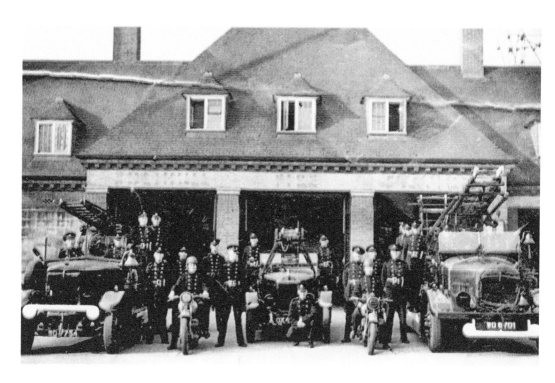

Fire Station
Officers pose outside the fire station, which has always been in Streetsbrook Road.

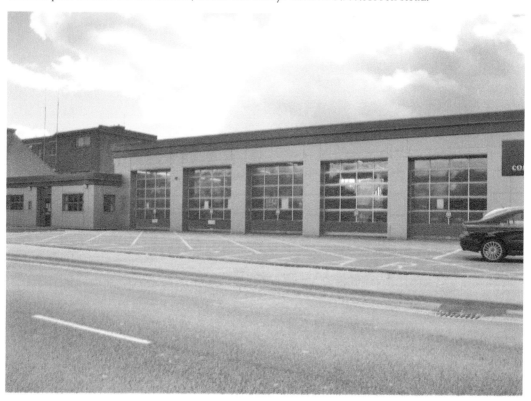

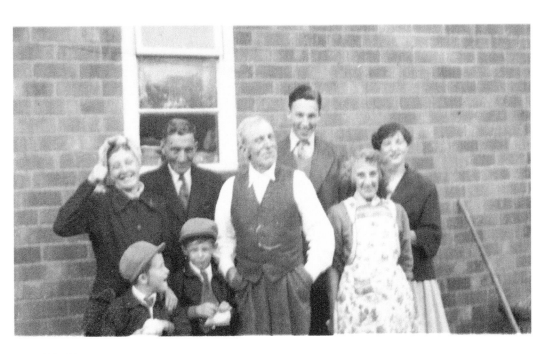

Workhouse

Another photograph taken at the rear of 42 Moat Lane, showing the Richards and Handy families. The elder members of the family would have recognised these buildings as the former workhouse.

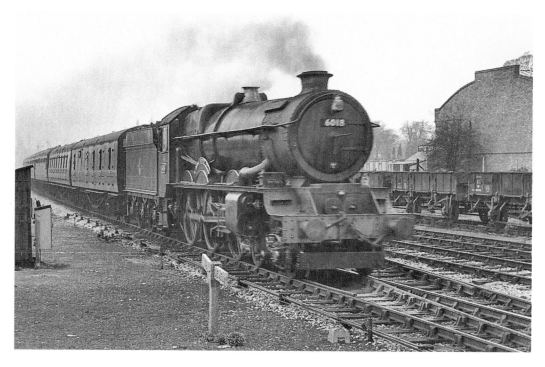

Solihull Station
No. 6018 *King Henry IV* steams through in April 1963. The station has changed greatly since, the number of operating lines having been halved.

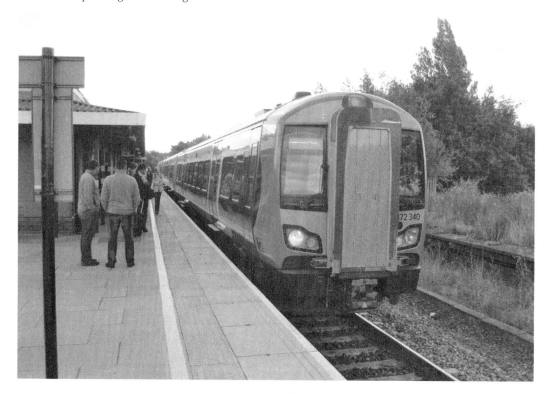

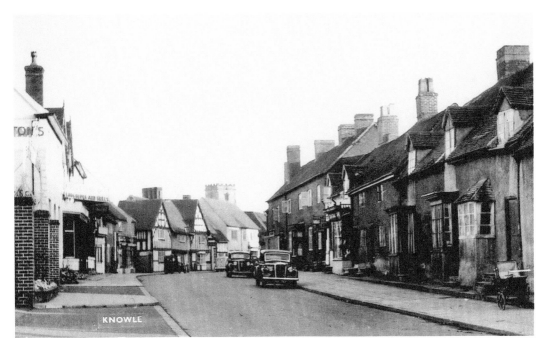

High Street Traffic

Looking south along the High Street from the Greswolde Hotel in the 1940s. Traffic volumes are infinitely greater today.

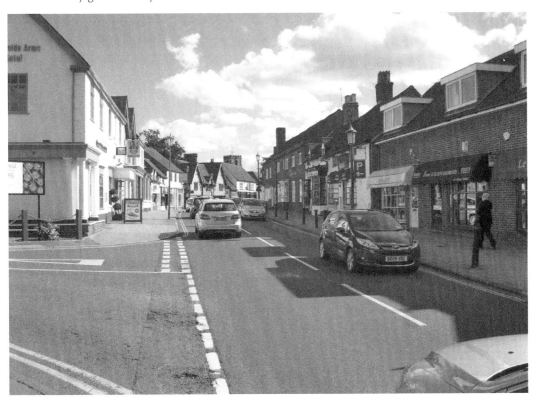

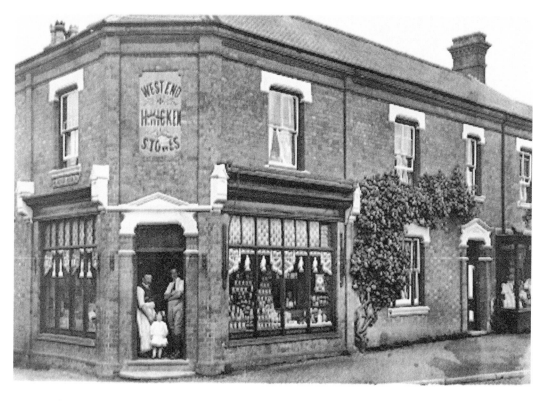

Hicken's Stores

The Hicken family in the doorway of their shop on the corner of Lodge Road and Station Road in the 1920s. Sadly, the old advertising panel has been obliterated instead of reused.

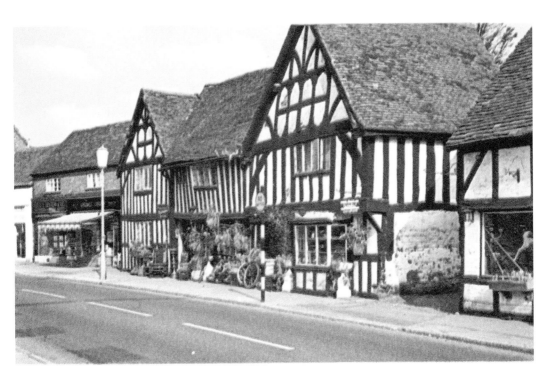

Chester House

Chester House was an antique shop in the 1960s and now houses the local library.

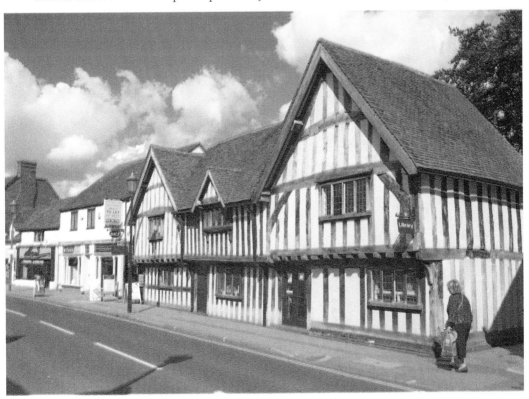

Bateman's
Bateman's in the High Street in the 1960s, long demolished and now home to the local shops.

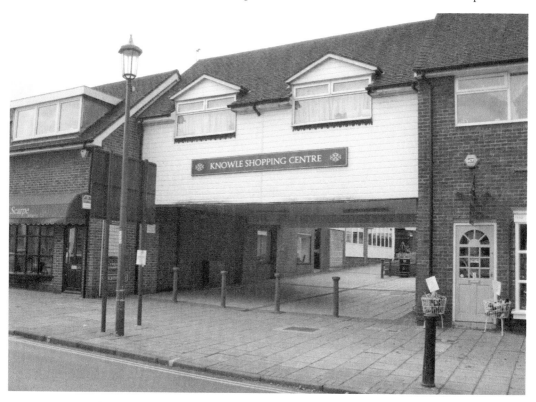

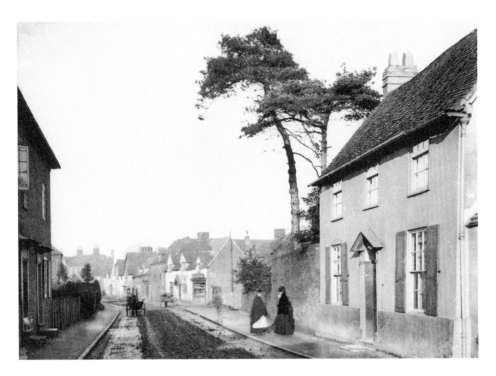

High Street Shoppers

Looking north along the High Street in the 1890s, with two women exchanging gossip. A century later and the attire may have changed but, once again, two ladies swap stories.

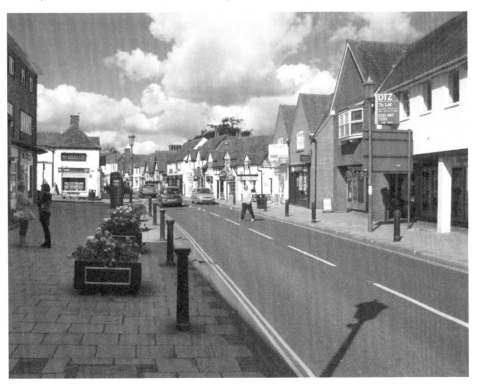

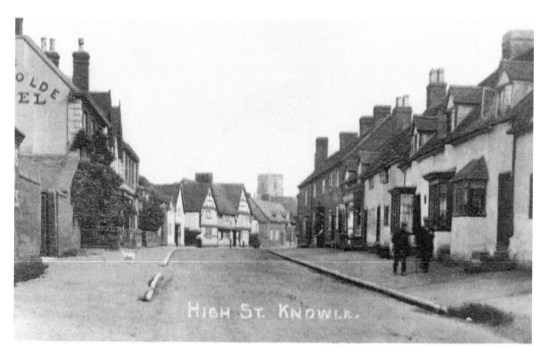

Greswolde Hotel

High Street in the 1920s with the side of the Greswolde Hotel on the left. It is compared with the modern side view of the same establishment.

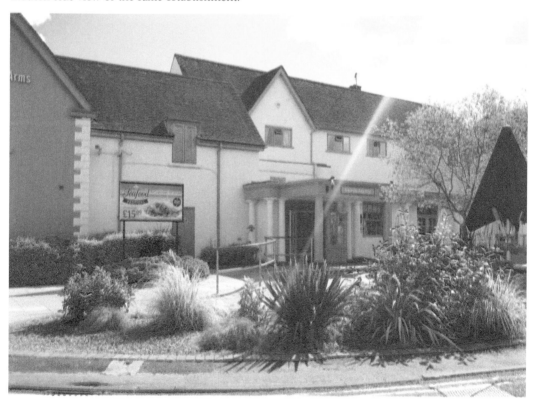

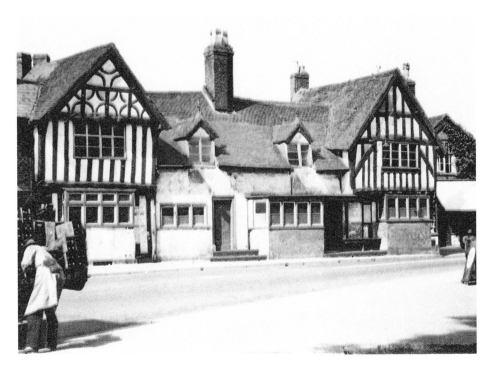

The White Swan

The White Swan before demolition in 1929; the date is commemorated by a brick in the new building above the middle upstairs window of the bank.

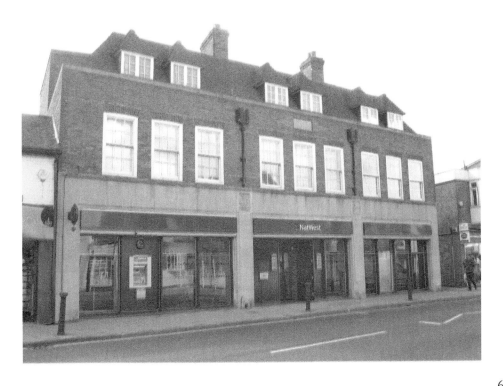

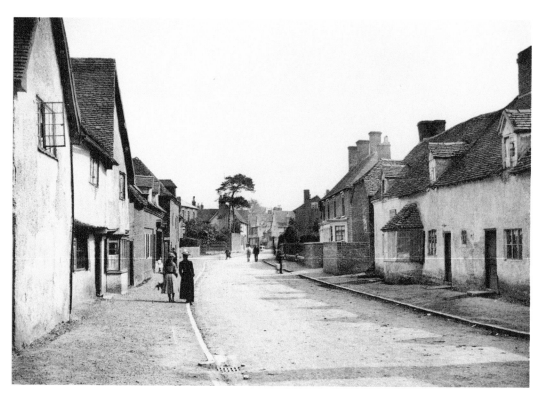

High Street
The High Street in 1896 and, looking the opposite way, in 2012. The same building appears in both photographs.

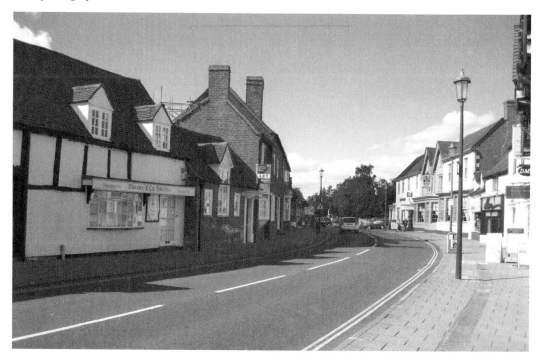

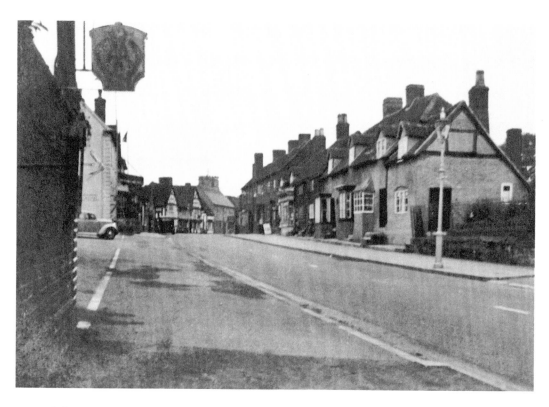

High Street
Another view of the High Street in the first half of the twentieth century.

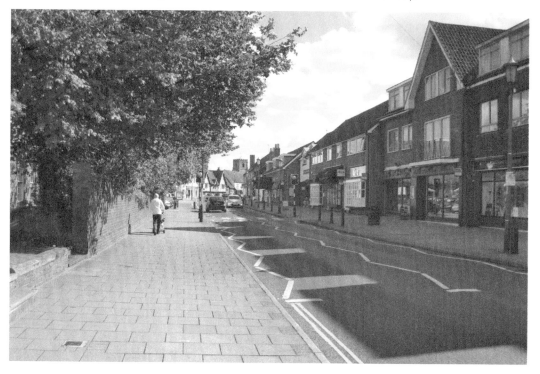

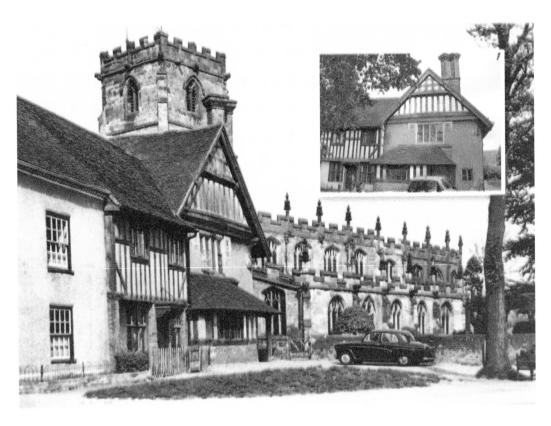

Knowle Parish Church
Knowle parish church and guildhouse in both 1970 and 2012.

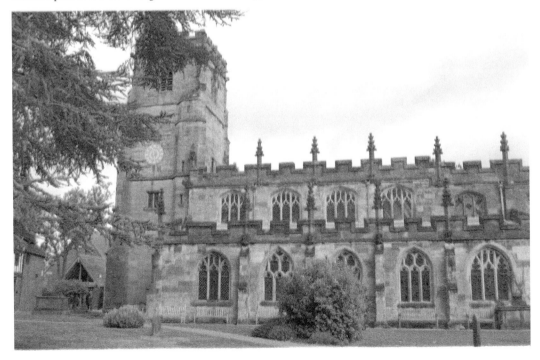

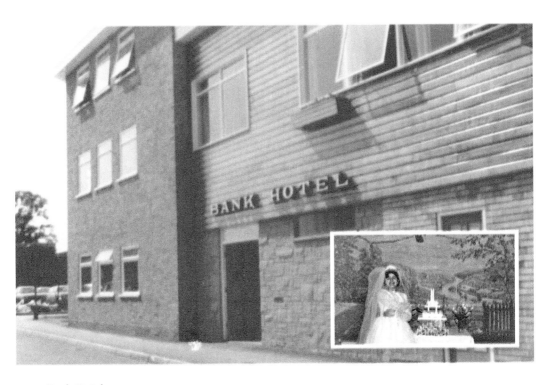

Bank Hotel

The Bank Hotel in 1970 and a wedding from around that time; note the memorable mural in the background. Today the Bank Vaults displays a sign showing the former use of these premises in Knowle.

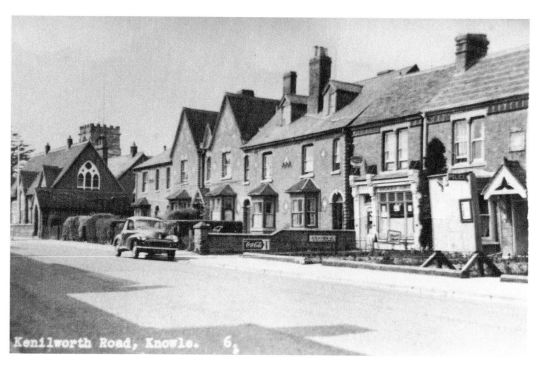

Kenilworth Road, Knowle. 6,

Kenilworth Road
Kenilworth Road, Knowle, was once home to local shops that are now private homes.

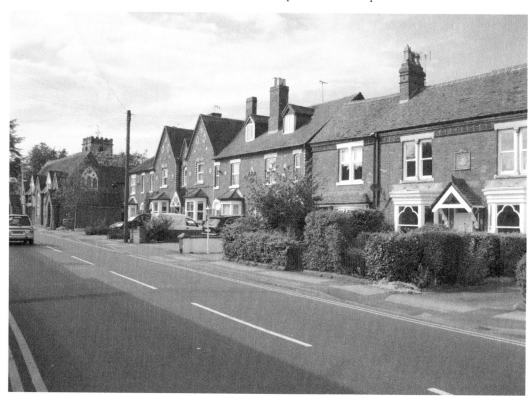

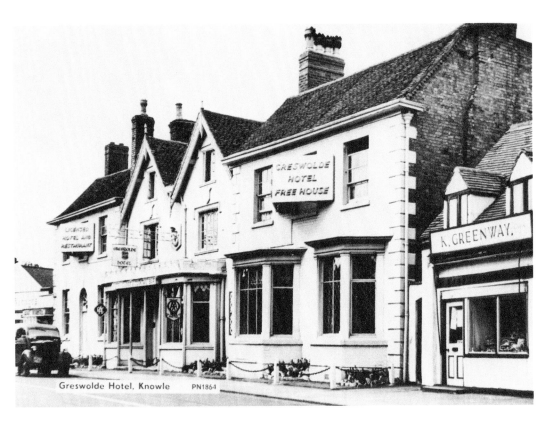

Greswolde Hotel, Knowle PN1864

Greswolde Hotel

The Greswolde Hotel in 1957 and again over fifty years later. During the Second World War the author's mother and her family slept in the back of their father's truck away from the bombing raids in Birmingham, in comparative safety.

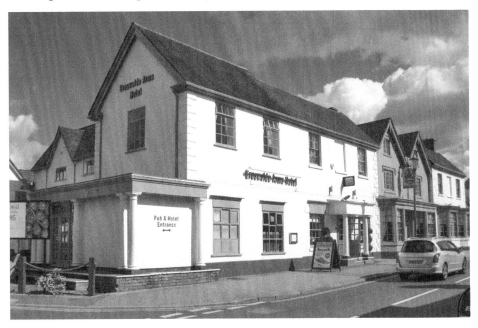

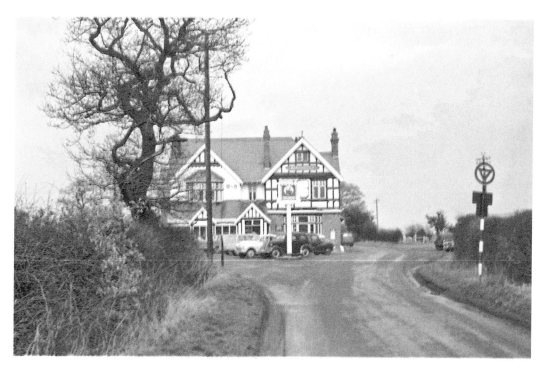

Red Lion

Earlswood's Red Lion has changed little on the outside since 1969, except for the outdoor seating replacing the car park, which is now wholly on the right. Inside, the traditional pub is now a restaurant.

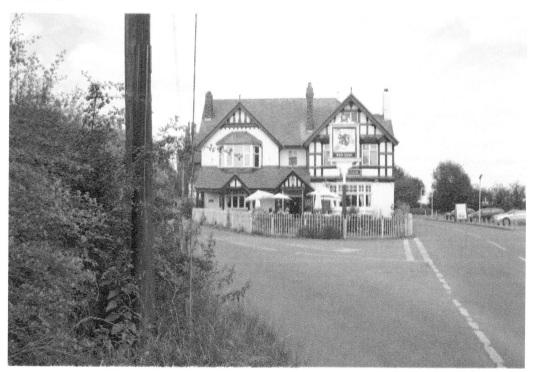

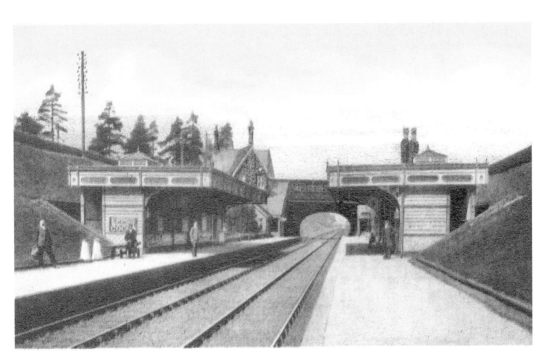

Hampton-in-Arden Station

Hampton-in-Arden's new station in 1906 and today. It is built away from the original site, which is found along Old Station Road.

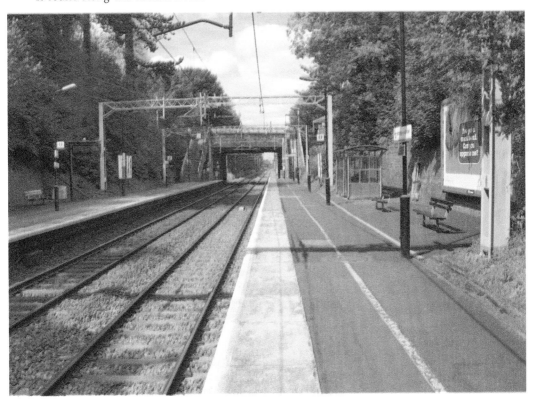

Village Green and Packhorse Bridge
The village green at Hampton-in-Arden in 1907. Even then it was very new compared with the Packhorse Bridge across the River Blythe. The bridge dates from at least the fifteenth century, when it provided a route to Kenilworth.

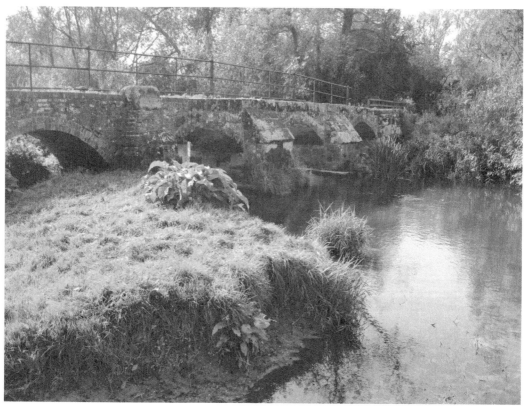

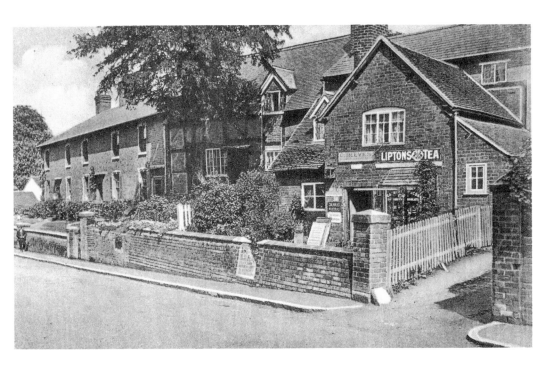

Village Stores
The village stores in Hampton-in-Arden as it appeared in 1920, and now as a private residence.

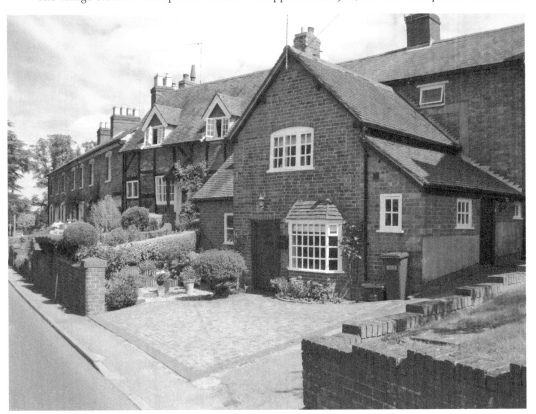

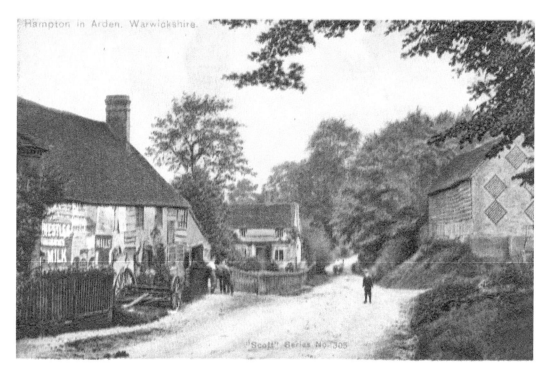

"Scott" Series No. 305

Blacksmith's

Hampton-in-Arden's blacksmith premises. This photograph, thought to have been taken in 1905, looks west from the church. The modern view looks in the opposite direction, along Marsh Lane. Today the area has much more vegetation and a narrower road.

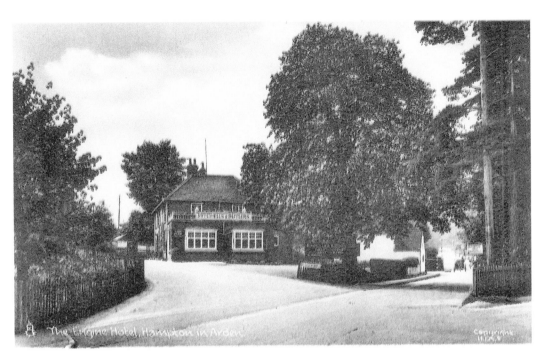

Engine Hotel

The former Engine Hotel, pictured here in the 1940s, has been demolished and replaced by a new development and is recalled only by the name of Engine Mews.

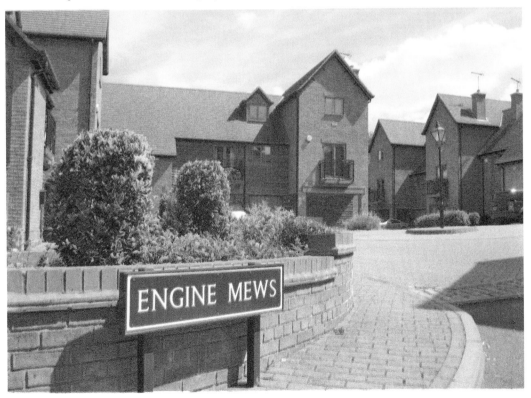

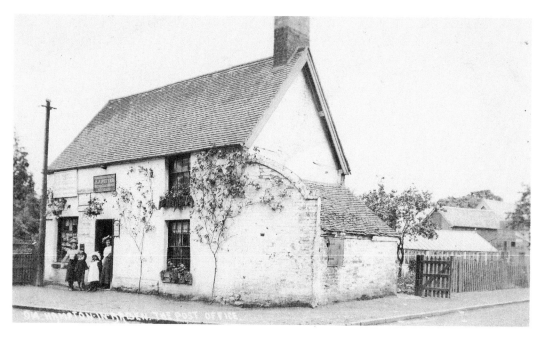

Post Office

Little change in Hampton-in-Arden's post office building since the earlier image in 1906. The arched wall on the right had to be rebuilt recently after being damaged when hit by a car.

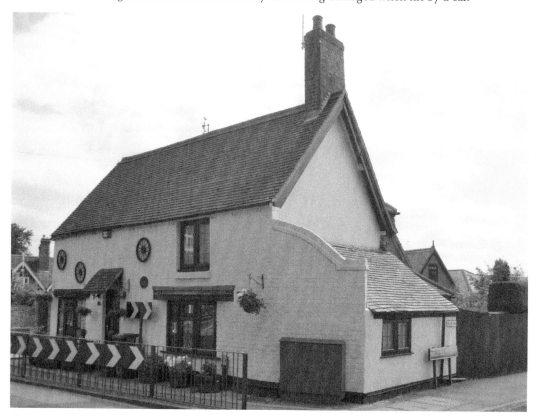

74

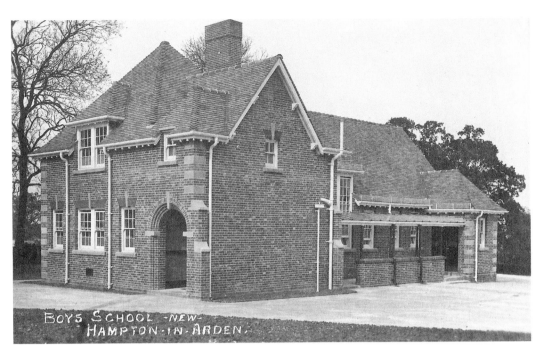

BOYS SCHOOL -NEW-
HAMPTON-IN-ARDEN.

Boys School

What was the George Fentham School for Boys in Fentham Road, pictured here in 1914, may have had an extension built onto it but otherwise has not a brick out of place.

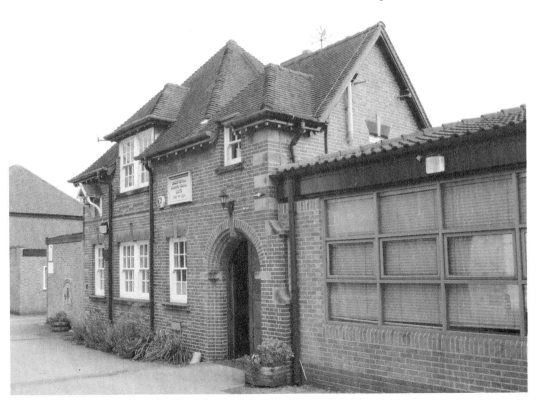

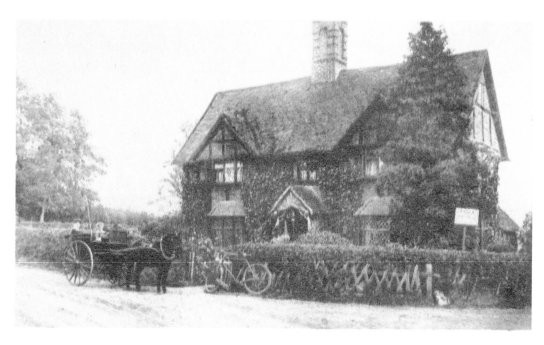

Blythe Cottage, Barston

Blythe Cottage at Barston in 1905. It has changed little in over a century. The most obvious change is the porch, previously supported by wooden sides, today by the living stems of honeysuckle.

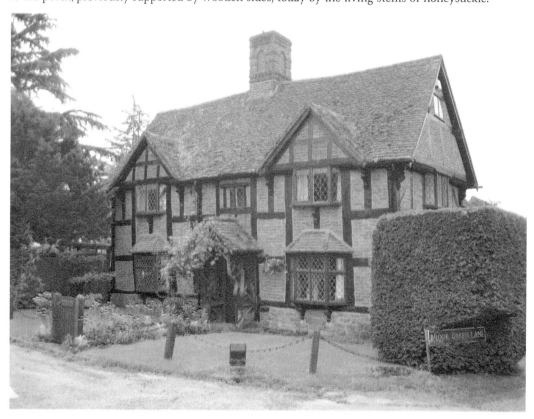

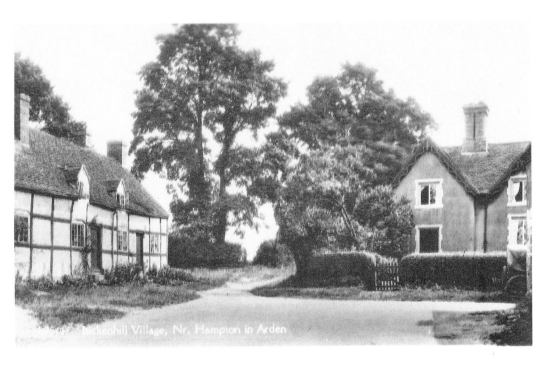

Bickenhill

Bickenhill in 1934 differs little from today, although the modern road surface has a camber to allow surface water to drain away, whereas before the Second World War it was quite flat.

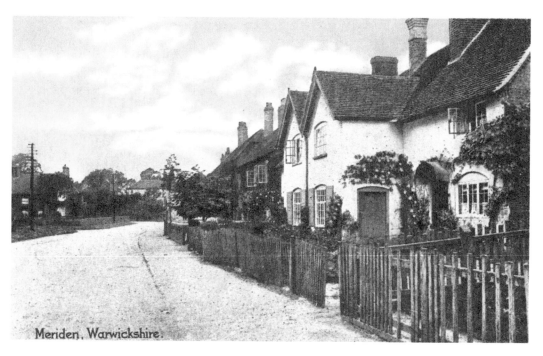

Meriden, Warwickshire.

Meriden

Meriden in 1910 and the same view today, albeit from a slightly different angle in order to see around the large tree. The famous old pub named the Bull's Head is just out of sight around the bend to the right.

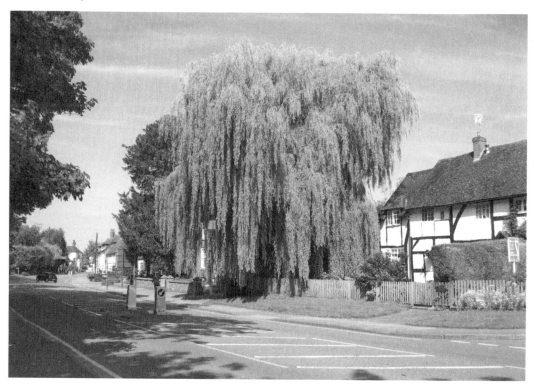

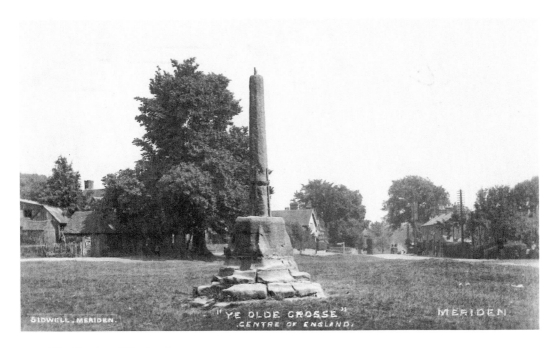

The Centre of England

This old cross in the centre of Meriden was claimed to mark the centre of England when this image was taken, possibly in the 1920s. Today the accepted central point is in Leicestershire, near the border with Warwickshire at Lindley Hall Farm, Fenny Drayton – which is approximately 11 miles to the north.

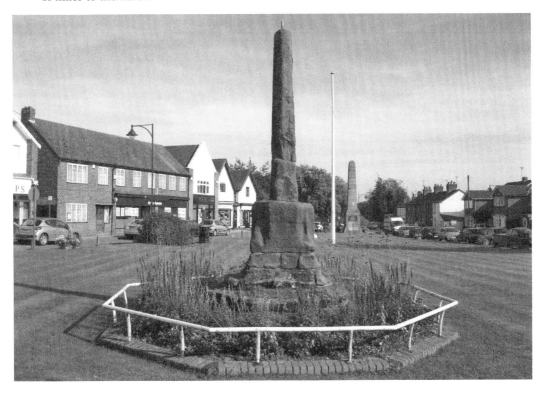

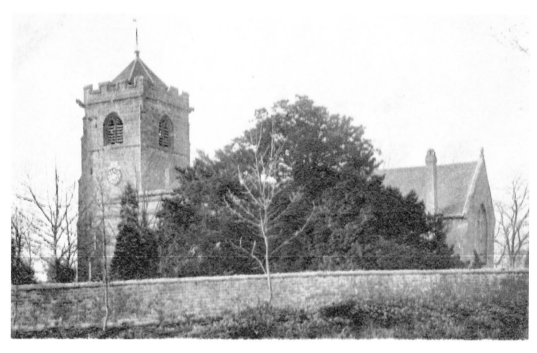

St Lawrence's Church

Meriden's church is dedicated to St Lawrence. As with other images, there are more trees in the modern image than a century ago.

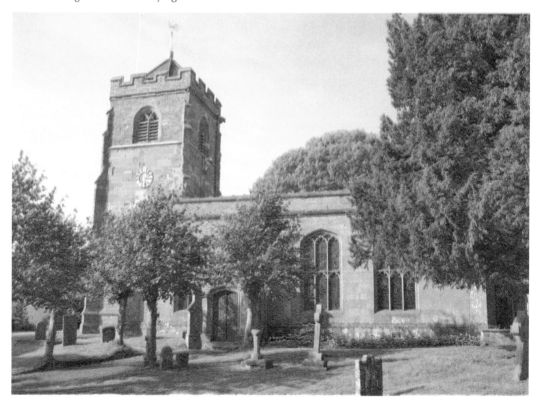

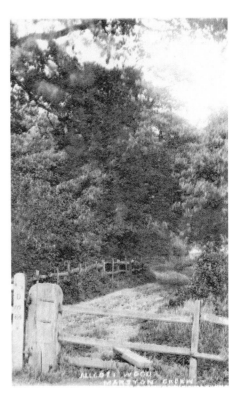

Allcot Wood Nature Reserve
Allcott Wood at Marston Green pictured in 1910 and a century later. The area is now designated a nature reserve.

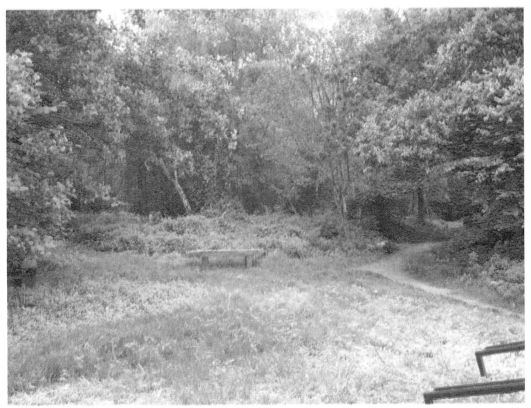

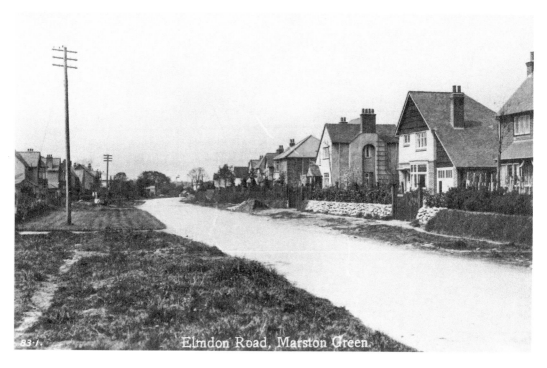

Elmdon Road

Elmdon Road, Marston Green, probably photographed in the years following the Second World War.

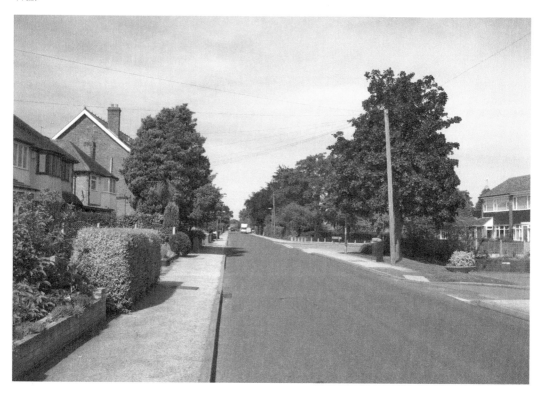

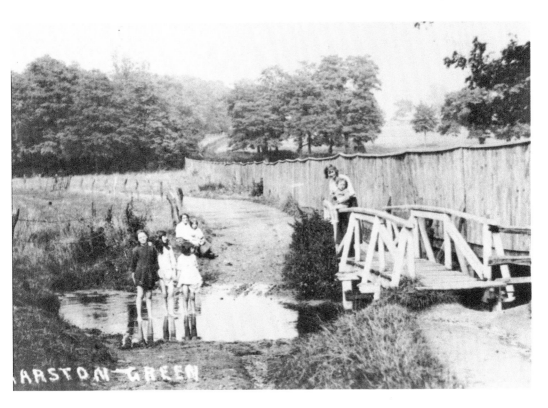

Bridge at Marston Green
This bridge over the river marks the point where Bell Lane becomes Holly Lane.

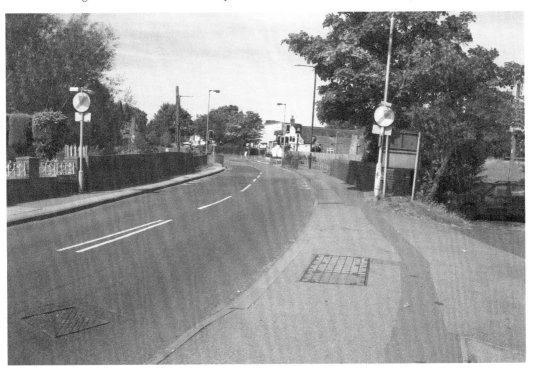

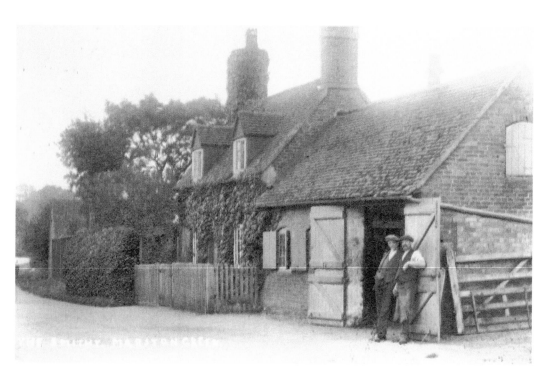

Bell Lane

The smithy at Marston Green is long gone, although the Bell Inn remains. Both were on Bell Lane.

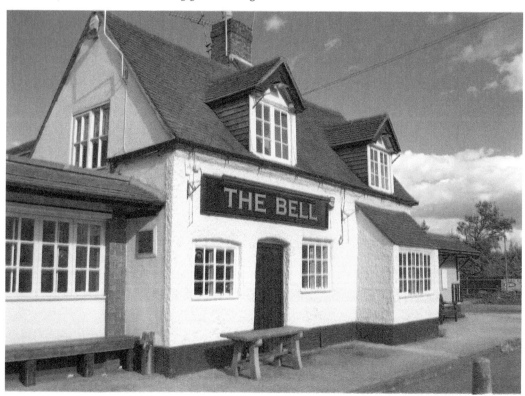

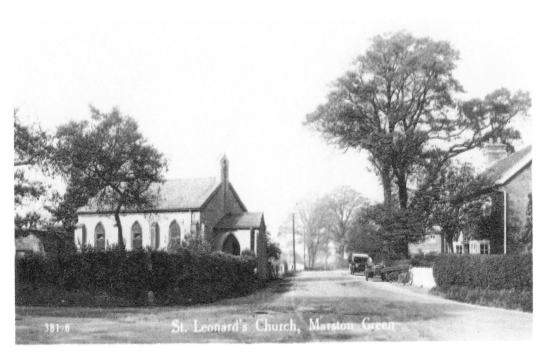

St. Leonard's Church, Marston Green

St Leonard's Church
St Leonard's church was once very easily seen. Today, the trees really do dominate the scene.

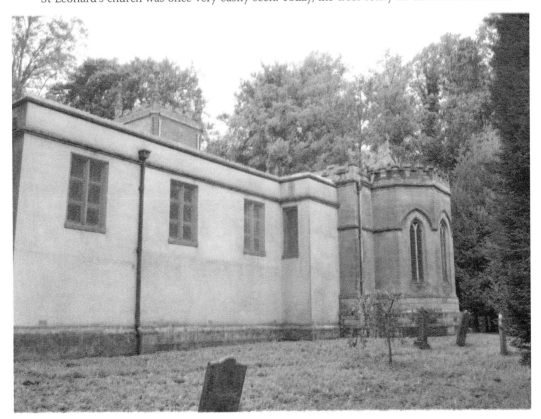

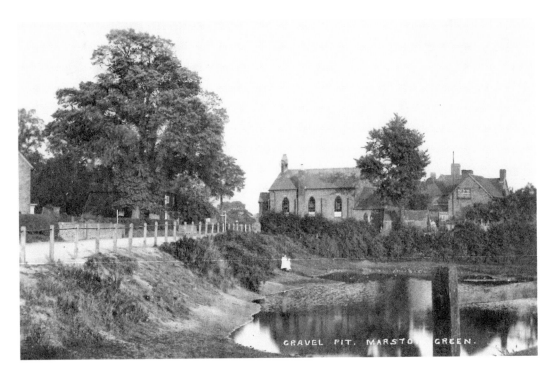

Gravel Pit

The gravel pit is now filled in and the whole area landscaped.

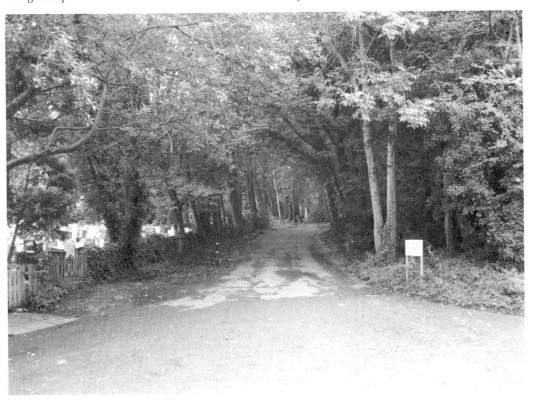

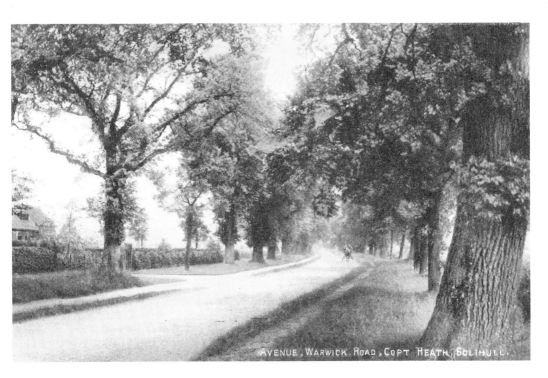

AVENUE, WARWICK. ROAD, COPT HEATH, SOLIHULL.

Copt Heath
The Avenue on Warwick Road at Copt Heath, with a similar view today.

Olton

Grange Road, Olton, retains a semi-rural appearance in the twenty-first century.

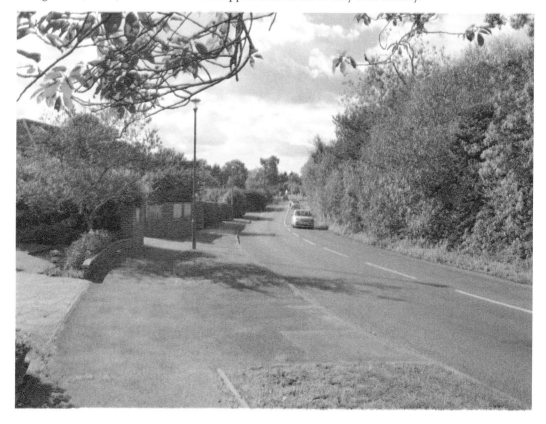

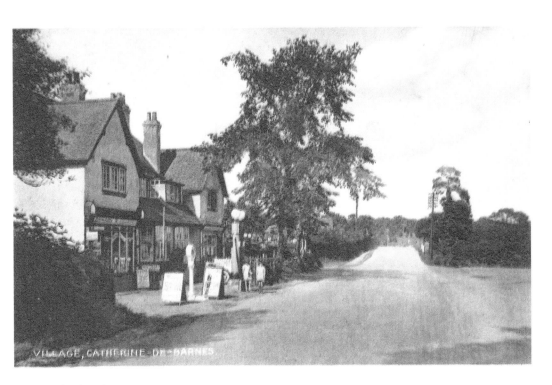

Catherine-de-Barnes

At Catherine-de-Barnes, the local shops have been opposite the Boat Inn for many years. On the left the old-style petrol pumps can be seen, while ahead the rise in the road is the bridge over the canal, which suggested the name of the local pub.

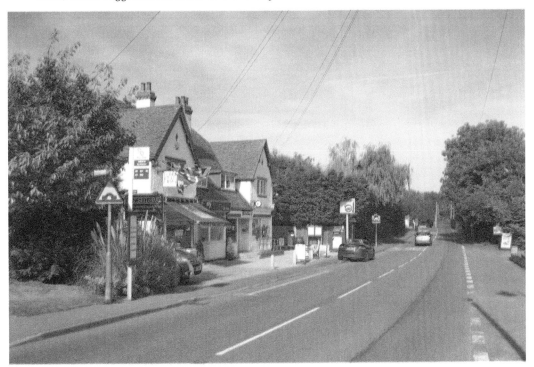

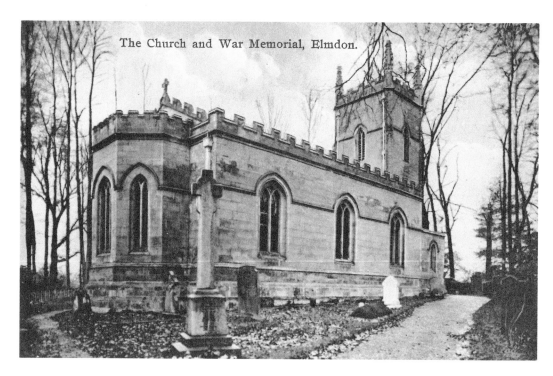

The Church and War Memorial, Elmdon.

Elmdon Church

St Nicholas church had few trees when this image was taken. Today the same view proved impossible to capture because of the vegetation, and so the opposite side of the building is shown.

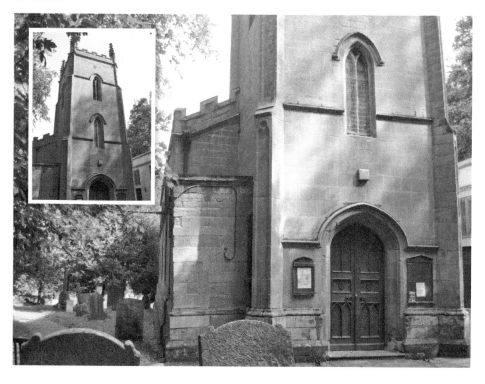

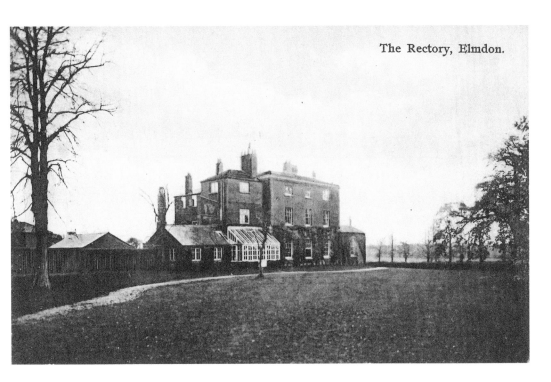

The Rectory, Elmdon.

Elmdon Park and Rectory
The former rectory at Elmdon, where the land around is given over to the delights of present-day Elmdon Park.

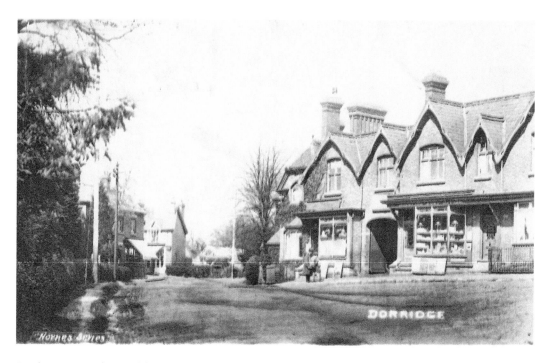

Station Approach, Dorridge
Dorridge, and the road to the right is Station Approach.

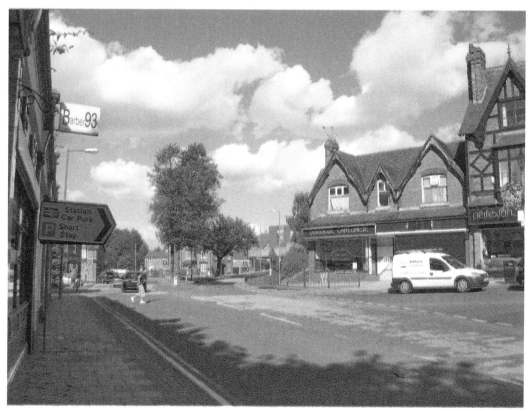

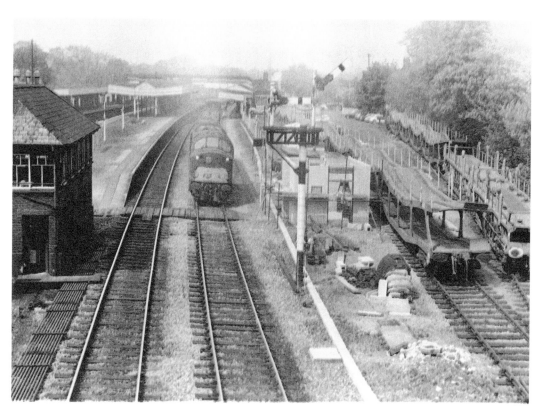

Dorridge Station
Dorridge station was once a hive of activity.

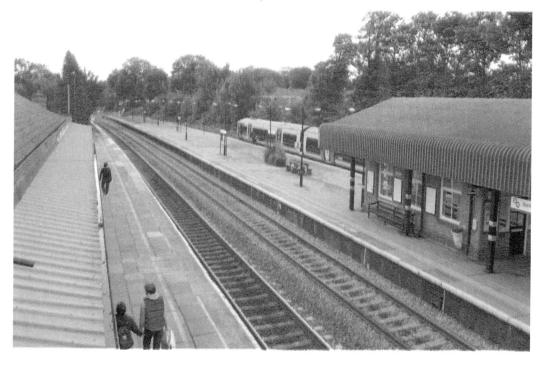

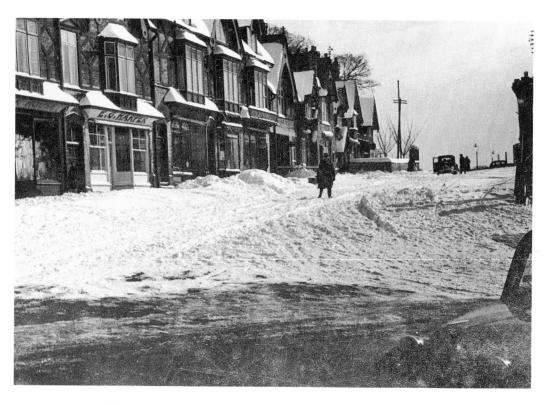

Snowy Dorridge
Dorridge after heavy snowfall, making underfoot conditions treacherous on this slope.

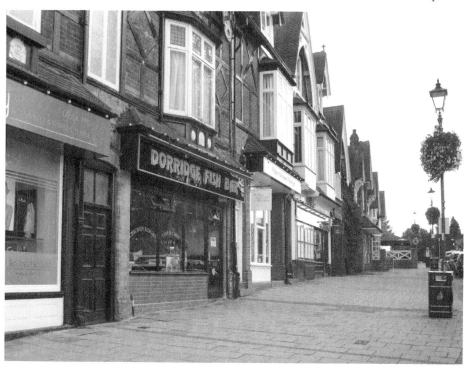

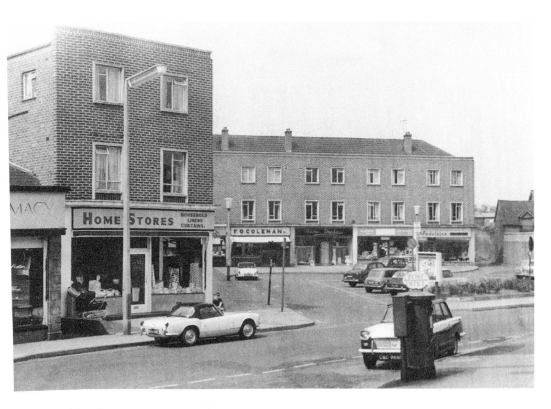

Dorridge Square
Parking at Dorridge Square was much easier in the 1970s.

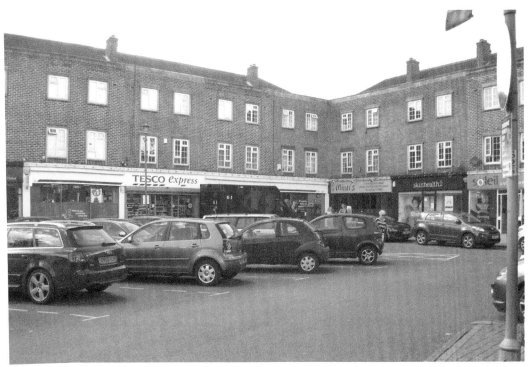

Bentley Heath

Widney Road, Bentley Heath – these images are separated by more than a century.